Kodak
Pocket Guide to
35mm Photography

Third Edition 1996 Fourth printing, 1999

Publication AR-22
Cat. No. E123 0861
Library of Congress Catalog Card Number 95-72630
ISBN 0-87985-769-2
Printed in the United States of America

Photo credit: page 49, top: © Bill Binzen

Kodak
LICENSED PRODUCT

The Kodak materials described in this book are available from
those dealers normally supplying Kodak products. Other materials
may be used, but equivalent results may not be obtained.

Kodak is a trademark of Eastman Kodak Company used under license.
Ektachrome, Gold, Kodachrome, Plus-X, Royal, T-Max, Tri-X, and Wratten are
trademarks of Eastman Kodak Company.

Kodak Books are published under
license from Eastman Kodak Company by
Silver Pixel Press ®
21 Jet View Drive
Rochester, NY 14624 USA
Fax: (716) 328-5078

CONTENTS

INTRODUCTION

What is the procedure for fill-in flash? Bounce flash? What should you know about using auto-focus cameras? Autoexposure modes? What is DX-encoding? What lens is best for taking sunset photographs? How should you expose for a rainbow? Fog scenes? Fireworks?

Few photographers know all the answers. Not even the experts. And with technology bounding ahead daily, it's hard to keep up with all the new camera features. But with this pocket guide in hand, you will have the answers when you need them most—in the field. You won't have to use trial-and-error and just hope for the best. You won't have to throw your hands up in disgust and wait until you get home to look up the answer in your coffee-table photography book. From now on you won't have to miss pictures because you didn't know what to do or how to do it.

Pick up tips on the very latest technology—from dedicated flash units to programmed exposure modes. Find out how you can exploit those new camera/computer hybrids to make better pictures as you learn the basic, intermediate, and advanced picture-taking techniques. Discover how to photograph oddball subjects like lightning, star trails, and moonscapes, as well as common subjects like landscapes, people, and animals. Learn about depth of field, exposure, and shutter-speed selection. And you'll even find practical suggestions for planning your travel photography: the equipment and film to take, what to expect from customs, and even how to photograph from an airplane during takeoff.

From birthdays to moon rises, from zoom lenses to polarizing filters, this guide will give you a wide range of information to answer your questions about photography. So get to it. Get out there and shoot some outstanding photos.

CAMERA CONTROLS

On some 35 mm cameras, knobs, levers, and scales seem to sprout everywhere. On other models, there are liquid-crystal display (LCD) panels, electronic switches and mode selector buttons. Fortunately, the controls of even the most sophisticated 35 mm SLR camera are logically organized and are simple to master.

The settings on virtually all 35 mm cameras adjust three basic picture-taking controls: the shutter speed, the aperture, and the focus. On some cameras you have to adjust these controls manually; on others, the camera sets them for you. Often, it is a combined effort of the camera and the photographer.

Whether you make the adjustments or let the camera do the thinking, knowing how each control affects the final image is the beginning of learning the skills you need to get the pictures you want.

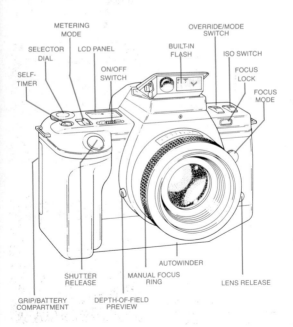

METERING MODE
OVERRIDE/MODE SWITCH
SELECTOR DIAL
LCD PANEL
BUILT-IN FLASH
ISO SWITCH
SELF-TIMER
ON/OFF SWITCH
FOCUS LOCK
FOCUS MODE
AUTOWINDER
SHUTTER RELEASE
MANUAL FOCUS RING
LENS RELEASE
GRIP/BATTERY COMPARTMENT
DEPTH-OF-FIELD PREVIEW

Shutter Speed

The shutter in most 35 mm SLRs is a travelling set of curtains or blades in front of the film plane. With manual and shutter-priority automatic cameras, you set the shutter speed, either with a mechanical dial or with an electronic switch.

For manual and aperture-priority automatic cameras, you set the lens aperture and the camera chooses a shutter speed for correct exposure. Programmed cameras set both the shutter speed and the aperture automatically. On many newer cameras, LCD panels display the exposure information.

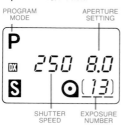

PROGRAM MODE — APERTURE SETTING — SHUTTER SPEED — EXPOSURE NUMBER

Fast shutter speeds contribute to sharp pictures by arresting camera and subject motion. A fast shutter speed, such as 1/500 second, freezes fast motion, but a slow shutter speed, such as 1/8 second, does not. Sometimes you don't want to stop action entirely because a certain amount of blur imparts a feeling of motion—in sports pictures, for example.

To avoid unwanted blur from camera movement, use a shutter speed no slower than the equivalent of 1 over the focal length of the lens (in millimeters), or the closest available speed. With a 50 mm lens, for instance, shoot at a shutter speed of 1/60 second or faster.

Most programmed cameras automatically choose a shutter speed safe for hand-held work, or warn you that the speed in use is not fast enough. Because longer lenses need faster shutter speeds to prevent blur from camera movement, many programmed cameras also automatically select faster shutter speeds if a telephoto lens is used.

In a pinch, you can use a shutter speed as slow as 1/30 second with a 50 mm or shorter focal length lens—but be careful to brace the camera against something solid, such as a fence rail or car fender. To avoid blur from camera movement, try to use the fastest shutter speed you can without sacrificing depth of field.

1/500 SECOND

1/8 SECOND

Aperture

The aperture is a variable opening formed by an adjustable diaphragm inside the lens barrel. Aperture size affects both exposure and the range of sharpness (depth of field) in the picture. A large aperture lets in lots of light and gives comparatively little depth of field. A small aperture lets in little light but gives great depth of field.

On aperture-priority automatic cameras, you adjust the aperture and the camera picks the shutter speed. On shutter-priority automatic cameras, you set the shutter speed and the camera selects an aperture that's appropriate for correct exposure. Programmed cameras select both the shutter speed and the aperture. Most programmed cameras also let you manipulate the settings when you want to.

f-Number and Aperture Size

Aperture sizes are indicated by f-numbers, which are also called f-stops. F-numbers can be confusing because a small number indicates a large opening and a large number indicates a small opening. The following f-numbers describe aperture sizes: $f/1.4$, $f/2$, $f/2.8$, $f/4$, $f/5.6$, $f/8$, $f/11$, $f/16$, $f/22$. Counting down from $f/22$ to $f/1.4$, each succeeding aperture lets in twice the amount of light as the higher-numbered one before it.

To keep f-numbers and aperture sizes straight in your mind, think of f-numbers as fractions. Thought of as a fraction, $f/2$ becomes 1/2 and obviously indicates a larger opening than $f/11$, which becomes 1/11.

Aperture and Depth of Field

Depth of field is the distance between the nearest and farthest objects that appear in focus in a picture. For a given lens, each successively smaller aperture increases the depth of field. Neither great nor little depth of field is inherently good. Sometimes you want one, sometimes the other. You might use a small aperture like $f/16$ to obtain more depth of field for a landscape picture. You might use a large aperture like $f/2$ to obtain less depth of field in a portrait so only your subject appears in focus against a blurred background.

APERTURE RING

f/16

f/11

f/8

f/5.6

f/4

f/2.8

f/2

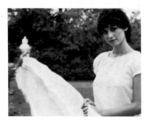

f/2.8

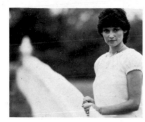

f/16

To determine depth of field for various apertures, you can use either the depth-of-field preview button, or the depth-of-field scale. Not all cameras have a depth-of-field preview button, but if yours does, simply push it in and the diaphragm will close down to the chosen aperture. Now you can look in the viewfinder and gauge depth of field for that aperture.

The depth-of-field scale doesn't show you the actual affect on the image, but you can use it to judge approximate sharpness. Found on most lenses, the depth-of-field scale is next to the distance scale. Pairs of marks on the depth-of-field scale correspond to specific apertures. Find the marks for the aperture in use—the distance they bracket on the distance scale is the depth of field for that aperture.

Maximizing Depth of Field

You can make the most efficient use of depth of field by using the depth-of-field scale and distance scale on your camera.

DISTANCE SCALE

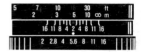

1. Focus on the nearest subject you want sharp, and note its distance as indicated by the distance scale. Here it is 7 ft (2 m).

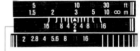

2. Focus on the farthest subject you want sharp, and note its distance. Here it is 15 ft (5 m).

DEPTH-OF-FIELD SCALE

3. Now turn the focusing collar until the near and far distances lie opposite the depth-of-field scale. Adjust the collar until you find the marks for the largest aperture that bracket the near and far distances. Use the aperture that corresponds to those marks. Here, the marks for f/11 just enclose the near and far distances of 7 ft (2 m) and 15 ft (5 m).

4. For more depth, use a smaller aperture, move farther away from the subject, or use a shorter focal length lens.

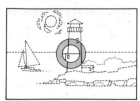

OUT OF FOCUS

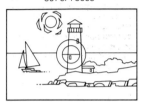

IN FOCUS

Stress with Selective Focus

Selective focus might be better called selective depth of field because it gives a shallow zone of sharpness.

The purpose is to rivet attention on the subject. Only the subject plane is sharp. The rest of the picture is unsharp.

Selective focus is most easily achieved by using a telephoto lens at a wide aperture like $f/2.8$ and focusing on a close- or medium-distance subject. With a normal lens set at a wide aperture, selective focusing works best with close subjects.

Manual Focus △

Although focusing has few pit-falls, sometimes you should be extra careful. Because of shallow depth of field, careful focusing is required when taking close-up and telephoto shots or when taking pictures in dim locations where it's hard to see.

Areas unsharp in the viewfinder may be sharp in the picture. That's because the aperture used for viewing and the aperture used for picture-taking are often different. The lens' widest aperture is normally used for viewing. For picture-taking you often use a smaller aperture that the camera sets only at the moment of exposure.

A smaller aperture means greater depth of field, thus more foreground and background are rendered sharper than indicated by the view-finder image. The moral? Use the depth-of-field preview button to see how sharp things appear at the aperture you've chosen.

Autofocus

Since an autofocus camera focuses on whatever is in the center of the viewfinder, pay close attention to what you put there. But what if you don't want your main subject dead center in the viewfinder? In such a situation, use your camera's focus lock. With your subject centered in the frame, partly depress the shutter button to lock in the focus, then reframe the scene the way you want it. If you want to focus on

10

another part of the scene, just release the shutter button and begin over again.

Autofocus cameras work best in well-lighted scenes with good contrast. When the light gets dim or the contrast is low (on foggy days, for example), autofocus systems may slow down or fail. To overcome this, focus on the part of the scene with the best contrast—the edge of a highlight or shadow, for instance.

Most 35 mm SLR autofocus cameras have an override mode that lets you focus the lens by turning the focusing collar—just as you would with any manually focused SLR camera. You can use the manual override when the light or contrast gets too low for autofocusing, or if there are two subjects at different distances within the small focus frame. You may also need to focus manually when there are parallel vertical lines in the frame. Check your camera instructions for focusing in special situations.

Autofocus Modes ▷

Moving subjects can present a challenge for autofocus systems. This is why some of the more sophisticated SLR autofocus cameras offer two autofocus modes: single shot for still subjects and servo for moving subjects. Single shot is best in most situations because it won't let the shutter open until the subject is sharply focused. Servo, or continuous focus, continuously refocuses as the subject distance changes—but it will let you trip the shutter whether the subject is sharp or not.

Depth of Field with Autofocus

Determining or controlling depth of field with an autofocus camera can be difficult because many autofocus lenses don't have a depth-of-field scale and the camera may not have a depth-of-field preview button. If your autofocus camera has neither of these, and it doesn't feature a special depth control mode, you can still manipulate depth of field if it has an aperture-priority mode. Use it to set a small aperture for great depth of field, or a large one for less depth.

Carry Your Camera Manual

Until you are thoroughly familiar with your camera, carry your camera manual with you. It will answer many questions on handling the camera and setting the controls of your particular model.

CAMERA CHECKLIST

Dead batteries. Mis-set film-speed dial. Wrong film. Such setbacks, always discovered too late, can leave you steaming. Fortunately, they are easily avoided. Establish a routine for checking out your camera gear before, during, and after a photographic session. Carry a small emergency pack containing the following:

Before-Leaving-the-House Checklist

1. Turn on the camera's battery test switch to check the batteries.

Emergency Pack

1. Spare batteries for camera and flash.

2. Two extra rolls of film.

3. Lens tissue and a camel's-hair brush for cleaning camera and lenses.

2. Check your film supply. Is it sufficient? Is it the film you need for the subjects you anticipate photographing? Do you have a few rolls of high-speed or slow-speed film just in case?

3. Check that you have the equipment you need: lenses, tripod, flash, extension tubes, etc.

Before-Shooting Checklist

1. Be sure you have film in the camera. Don't rely on the mechanical frame counter—you may have idly cocked and released the shutter when the camera was empty.

Some cameras have a film window or an LCD display to tell you if the camera is loaded. If yours doesn't, you can check if there's film by gently turning the rewind knob in the direction of the arrow on the knob. If it resists turning within two revolutions, the camera is loaded. Don't turn the knob backwards.

2. Be sure that the film-speed dial is correctly set for the film you are using. If you have DX-encoded film in a code-reading camera, the camera will automatically set the film speed.

3. With an automatic camera, check that the compensation control is at neutral.

4. Turn on the exposure meter. Many cameras will not operate until the exposure meter is actuated.

FILM

The two basic film types are negative and slide (reversal). Negative films produce prints. Slide films, generally available in color only, produce slides for projection, but you can also have prints and enlargements made from slides. Most color and black-and-white negative films offer greater exposure latitude; that is, you can moderately overexpose or underexpose the film and still get acceptable prints. The latitude is greater in the overexposure range—allowing as much as 3 stops of overexposure. Color negative film is especially useful in high contrast lighting since you can overexpose by 1 or 2 stops to show more detail in dark shadow areas and still get a good quality print. Of course, you will get the best results by using accurate exposure. Color-slide films have much less latitude than most negative films, seldom more than ± 1 stop. If you can't achieve optimum exposure with color slide films, you will usually get better results with slight underexposure than with overexposure.

Film Speed

The speed of a film, designated by an ISO or ASA number, indicates the film's sensitivity to light. For commonly used films, ISO numbers range from 25-1000. High ISO numbers, such as 400, mean the film is more sensitive to light than a film with a lower number. An ISO 400 film is twice as sensitive to light as an ISO 200 film.

Films are classified by their speed. The four classes of film speed are low, medium, high, and very-high speed. Low-speed films, ISO 50 and under, are easily used outdoors on sunny days. Medium-speed films, ISO 64-200, work well outdoors on sunny and moderately overcast days and indoors with flash. Low-and medium-speed films are best for capturing fine detail.

High-speed films, ISO 250-640, work well in the dim light of indoors and the bright light of outdoors. Outdoors, they give you fast shutter speeds to stop action and indoors they let you

handhold the camera to take pictures without flash. They also work well with flash, giving you greater depth of field than do slower films. Very high-speed films, ISO 800-1250, excel for existing-light photography, such as night sports events, parties, and stage shows. With a very high-speed film in your camera, if you can see you can probably photograph.

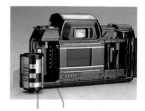

DXN CODE CAMERA SENSORS

DXN-Encoded Films

The containers for most 35 mm films have a checkerboard code (DXN code) on them that provides DXN-compatible cameras with

13

information about the film you're using. DXN-encoded films can tell auto-exposure cameras the film speed, the number of exposures, the film type, and information about the film's exposure latitude. Motorized cameras can use the information to trigger automatic rewind at the end of the roll.

Manual-Loading Cameras

1. Set the film-speed dial to the ISO (ASA) of the film.

2. Remove the film from the package in the shadow of your body.

3. Insert the film into the camera, still shading it with your body.

4. Advance the film until the drive gears engage *both* rows of sprocket holes.

5. Close the camera back.

6. Advance the film and press the shutter release until the frame counter reaches "1." You are now ready to begin shooting.

Manual Rewind

1. When the roll of film is completely exposed, depress the rewind button on the camera.

2. Unfold the rewind knob and turn it in the direction indicated on the knob until the film is completely wound into its magazine.

3. Pull up the rewind knob to open the camera back. On some cameras, you lift a latch along the side of the camera to open the back. Remove the film.

Auto-Loading Cameras

1. If you're in the sun, shade the film and camera with your body throughout the loading procedure.

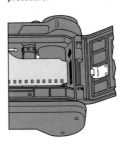

2. Insert the film into the camera with the film leader facing the take-up reel. Align the film with the film-load mark, and be sure to engage the film sprocket holes with the teeth on the take-up reel. Don't press on the film when it's lying across the camera or you may damage the camera shutter.

3. Close the back cover of the camera; the film will advance automatically to the first frame. Many auto-load cameras have a visible or audible warning to tell you if the film hasn't loaded correctly.

Automatic Rewind

Many auto-loading cameras also feature auto-rewind. After the last exposure, the camera will automatically rewind the film. Some cameras have an audible tone or a blinking light that signals you to push a rewind switch. One caution: If your auto-rewind camera leaves a small tail of the film leader sticking out of the magazine, be sure to wind the film manually all the way into the magazine. This will prevent you from accidentally re-using the film.

Increasing Film Speed

The speed of KODAK EKTACHROME Films and Kodak black-and-white films can be doubled and then specially processed. Doubling the speeds of KODAK GOLD and KODACHROME Films is not recommended. Given a choice, you usually get better results by choosing a faster film rather than changing the speed of a slower film.

Why double film speed? To get faster shutter speeds and smaller apertures (more depth of field) for existing-light and action photography. To double film speed, set the film-speed dial at double the ISO speed of the film. Shoot the entire roll at the doubled speed. Mark the roll so you know you doubled its speed. Tell your photofinisher you doubled the speed and ask for the appropriate processing.

TUNGSTEN FILM DAYLIGHT FILM

Color Balance

Color films are color balanced for either daylight or tungsten light. Daylight film used in tungsten light produces orangish pictures.

Under fluorescent light, daylight film often yields pictures with a greenish cast. Tungsten film used outdoors gives a bluish cast to pictures.

If you can't match the film to the light source, use a color negative film. It can be color corrected during printing to give nearly normal colors. You can also use light-balancing or conversion filters to correct color when mismatching film and light source (see p. 39). Black-and-white films work well with all common light sources.

Choosing a Film

Generally you should select a film with a speed appropriate for the amount of light. Use a high-speed film for dim light and possibly a medium- or slow-speed film for bright light. Also consider the need to stop action or obtain great depth of field; both requirements suggest medium- or high-speed film.

If using color film, choose one balanced for the light source you'll be working with. Also decide whether you want prints or slides.

For general photography, medium-speed films are the most flexible. They're fast enough to be used outdoors on overcast days yet slow enough to allow a wide choice of shutter speeds and apertures on sunny days.

If you plan on making enlargements larger than 11 x 14 inches with 35 mm film, consider using a slow- or medium-speed film for best results.

KODAK ROYAL GOLD FILMS

These technically advanced films are designed for 35 mm SLR cameras. They offer exceptional quality for photographers who require more than general-purpose films can provide.

KODAK ROYAL GOLD 25 Film has the finest grain and highest definition available in a 35 mm color negative film. It produces sharper images with greater detail in prints of any size and yields enlargements of superb clarity.

KODAK ROYAL GOLD 100 Film has better sharpness and finer grain than any other color print film with comparable speed. This medium-speed film produces prints with great sharpness and color.

With very high film speed and wide exposure latitude, KODAK ROYAL GOLD 1000 Film is well suited for low-light conditions. It also lets you use fast shutter speeds to stop action or use small apertures for greater depth of field.

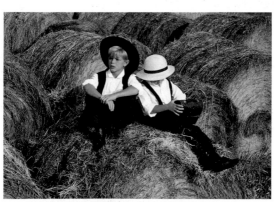

25-SPEED FILM OFFERS THE FINEST GRAIN AND SHARPNESS AVAILABLE IN A 35 MM COLOR NEGATIVE FILM AND PRODUCES ENLARGEMENTS OF SUPERB CLARITY.

EXPOSURE

Automatic exposure makes accurate exposure a cinch, right? Well... not always. For perhaps three-quarters of the pictures you take, the light meter in your camera tells you or your automatic camera the correct exposure. For the remaining quarter, it may be wrong. It may be wrong technically or it may be wrong creatively, and you must know when to overrule its recommendations.

Technically a meter may fail to give good exposure data when confronted with contrasty scenes or subjects that are much darker or lighter than normal. Creatively it may fail because it cannot tell you when to underexpose to make a silhouette or to create a sense of gloom or when to overexpose to lighten colors. Even the finest exposure meter lacks discretion and taste.

Exposure errors are most obvious in slides. Unlike prints from negatives, slides have no printing stage during which compensation may be made for exposure errors.

SPECIAL CONSIDERATIONS

Bracketing. If you aren't sure of the correct exposure, bracket. Start with your best estimate for correct exposure and take a picture. Take a second picture at 1 stop more, and then a third at 1 stop less than your first exposure. You can change either the lens opening (*f*/stop) or the shutter speed, depending on the situation. Some program cameras let you set the bracketing range (1 stop, for instance). The camera then automatically makes exposures at normal, plus 1 stop, and minus 1 stop. Full-stop increments are most effective with negative films, while 1/2-stop changes are better for subtle control with slide films.

What Is Exposure?

Exposure is the amount of light that reaches the film; it's controlled by the aperture and the shutter speed. The aperture size determines the intensity of the light striking the film. The shutter speed determines the length of time it strikes the film.

The camera exposure meter indicates appropriate aperture and shutter-speed settings. It correlates the amount of light reflected from the scene to the speed (sensitivity) of the film.

EQUIVALENT EXPOSURES

			1/250 SEC
			f/5.6
		1/125 SEC	
		f/8	
	1/60 SEC		
	f/11		
1/30 SEC			
f/16			

Every combination of *f*-stop and shutter speed the meter indicates has other equivalent settings that you can use to get the same exposure. To figure an equivalent setting, just remember this: The standard *f*-numbers for aperture sizes and the numbers for shutter speeds are in steps that double or halve the exposure. Going from *f*/8 to *f*/5.6, or from 1/250 second to 1/125 second, doubles the light. Each doubling or halving of exposure is called a stop. Going from *f*/8 to *f*/5.6 is a 1-stop change, and going from 1/250 to 1/125 second is also a 1-stop change.

Therefore, if you decrease the shutter speed (make it slower) by 1 stop, you have to make the aperture 1 stop smaller to keep exposure the same. If you increase the shutter speed by 1 stop, open the aperture 1 stop. For example, as the table shows, a setting of 1/125 at *f*/8 is the same as 1/250 at *f*/5.6 or 1/60 at *f*/11. If you have an automatic camera with an LCD exposure display, you may be able to set any number of equivalent exposures by simply turning the input dial.

Which combination of shutter speed and aperture should you use? Base that decision on four possible needs: a fast shutter speed to stop action or camera movement; a slow shutter speed to blur action; a small aperture for great depth of field; and a large aperture for shallow depth of field.

−1 STOP

Underexposure

With underexposure, too little light reaches the film. Bright highlights lose brilliance and shadow areas lose detail.

Correct Exposure

With correct exposure, enough light reaches the film to show some detail in both shadows and highlights.

Overexposure

With overexposure, too much light reaches the film. Details in bright areas of the picture are lost and shadows show too much detail.

EXPOSURE MODES

Although automatic-exposure cameras help you get correct exposure, they still leave you with the creative decisions to make. Most automatic SLR cameras offer several exposure modes—and the more sophisticated the camera, the more mode options you have to choose from.

Why does a camera that's supposed to be automatic need help from you? Because, different subjects require different apertures and shutter speeds. Settings that just provide the correct exposure may not be creatively right for the situation.

With some exposure modes, you make part of the exposure decision—setting either the aperture or the shutter speed—and the camera completes the process. In others, you just turn the camera on and it sets all controls automatically. Or, you can shut down the automation entirely and use the camera in full manual mode. Yes, automatic cameras do leave you with choices—but they are mainly creative choices, designed to help you tailor exposure to your own artistic tastes. Here are the basic auto modes and when to use them:

Aperture Priority

In this mode, you choose the aperture and the camera picks an appropriate shutter speed. Use this mode when you need to extend depth of field (with a small aperture), or to accentuate a subject with shallow depth of field (with a large aperture).

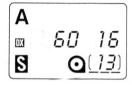

Shutter Priority

You choose the shutter speed and the camera sets the aperture. Shutter priority is a good all-around mode because it allows you to choose a safe shutter speed. Use a fast shutter speed to halt action or a slow one to blur it.

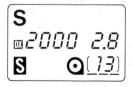

Normal Program

The camera sets both the aperture and the shutter speed automatically. This is the convenience mode; in most average daylight situations, it produces good exposure. When the light level permits, the program mode sets exposure to give both a safe shutter speed and moderate depth of field.

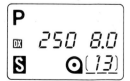

19

Special Program Modes

Some cameras also offer special modes that favor a fast shutter speed or a small aperture. In the DEPTH-OF-FIELD mode, for example, the camera will set the slowest shutter speed safe for hand-holding the camera, then give you the smallest possible aperture. In the ACTION mode, the camera will choose the fastest possible shutter speed for the lighting conditions. Some cameras will automatically switch to these special modes when you mount different focal length lenses: shifting into the depth-of-field mode with wide-angle lenses, for example, or to the action mode with a tele-photo lens. At least one 35 mm SLR camera on the market even has interchangeable computer cards that are programmed for special applications—close-ups, sports, bracketing, etc.

Matrix-Metering Modes

How do automatic exposure systems handle complex lighting situations and produce accurate results? One method that many sophisticated SLR cameras use is called "matrix" or zone metering. In this mode, the area viewed by the camera is divided into a pattern of segments (usually from 5 to 7 separate areas). The brightness in each area is then compared with known exposure information stored in the camera's computer chips. If your camera features matrix-metering, ignore the exposure compensation suggested in this book.

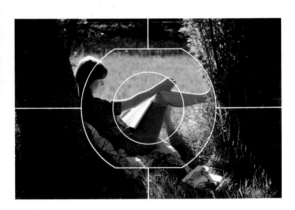

VARYING AUTOMATIC EXPOSURE

Most automatic cameras offer at least one (and usually several) ways to override the automatic exposure system. On some cameras, you activate these functions by pressing a button, switch, or electronic dial.

Exposure Compensation

This may be a mode selector switch on newer models or a dial on older cameras. Exposure changes are typically in a range of ±2 or 3 stops in half-stop increments. Use the minus settings to decrease exposure and the plus settings to increase exposure. Be sure to reset the exposure system to normal after taking the picture.

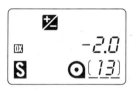

AE Lock

Also called metering memory, use this mode to take and hold selective meter readings from important areas of the subject. You can recompose the picture without affecting the exposure.

Spot-Metering Mode

This mode takes a meter reading of only a small area of the subject—usually marked by a circle in the center of the viewfinder. Spot-metering is the best way to get correct exposure for a small but important subject area—such as the face of a backlighted subject.

Film-Speed Dial

On cameras without exposure compensation controls, you can alter exposure by intentionally changing the ISO film speed setting. To increase exposure by 1 stop, change the setting to half the film's rated speed. To decrease exposure by 1 stop, double the speed. Reset the dial to the correct film speed after taking the picture.

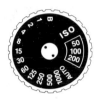

Metering Your Hand

The palm of the hand is a good metering target when you can't move in close to determine exposure of a normally bright subject. Open up 1 stop from the meter reading of your palm (use $f/8$ if meter indicates $f/11$). Make sure your hand is lighted the same as the subject. This method works well for everyone, as variation in the skin tone of the palm is usually slight enough to be ignored.

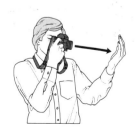

When in Doubt: Meter Close-Up

One way to determine correct exposure for a subject under tricky lighting conditions is to take a close-up meter reading of the main subject. Note the settings indicated (or use the memory/exposure lock if your camera has one), move back and frame the scene, and manually adjust the camera to use the settings indicated by the close-up meter reading.

1/Film Speed: Meter Check

The exposure for an average frontlighted subject on a sunny day is 1/film speed at f/16. Use this simple fact when your meter seems inaccurate or isn't functioning. Example: Exposure for film with ISO 64 is 1/60 sec, f/16.

Use Slide Film for Creative Exposure

Creative exposure works best with slide film. Slides return from the photofinisher in final form. The lab won't try to lighten or darken slides to produce a "normal" image as it does with prints from negatives. To experiment for deep, rich colors with slide films, underexpose by ½ to 1 stop but be sure to make a normal exposure, too.

Lightness—Airiness ▷

Here the photographer overexposed slide film by 1 stop and used a soft-focus lens to create a delicate, high-key effect.

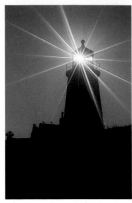

Making Silhouettes △

Silhouettes simplify. They turn a thousand details into dark and light masses that stress shape. To make a silhouette with the sun in the scene, set the exposure for the bright sky next to, but excluding the sun. Here, a star filter produces multiple points of light.

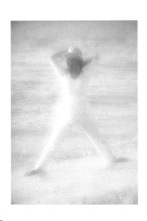

ELECTRONIC FLASH

Electronic flash not only provides light in dim places, it is useful in close-ups, action, and portraiture. Batteries provide the power, so keep fresh ones handy.

Many SLRs feature built-in flash. Most also accept an accessory flash you attach to a bracket or hot shoe on the camera. Built-in flash is usually completely automatic and often features through-the-lens (TTL) metering for very accurate exposure. Although its range is limited because of its small size, built-in flash is convenient and easy to use.

Accessory flash units, either automatic or dedicated types, are generally more powerful than built-ins. The automatic units have a sensor that measures the light reflecting from a subject. When enough light reaches the sensor, the flash shuts off. You can use a non-dedicated automatic flash on virtually any 35 mm SLR camera. Dedicated flash units, however, are designed for specific cameras. The camera and flash exchange information to automatically set lens openings and shutter speeds. Many dedicated units also feature TTL exposure control. Whether you're using direct, bounce, or fill-in flash, exposure control is fully automatic and very accurate.

Using Dedicated Flash

Using dedicated flash is very simple—particularly with a programmed camera—because the flash and camera will make all the settings. All you have to do is mount the flash in the camera's hot shoe, set the camera to "P," and turn the flash on. You may have to set the film speed on the camera, but if it is DX-code compatible, even this step is done automatically. On some dedicated flash units, you may have to set a flash switch to "TTL" so that it is the proper mode.

In the programmed mode, the camera will automatically set the proper sync speed (shutter speed) and the lens aperture. The selected combination usually appears on the flash-unit LCD panel or on the camera LCD panel (or both). It's often possible to use a specific aperture (for depth-of-field control) or a

different shutter speed within the sync range (a slower speed to increase background exposure, for example). See your camera and flash manuals for specifics.

Other features of most dedicated flash/camera combinations are viewfinder displays for a flash "ready" light and a sufficient-light indicator (to tell you that correct exposure has been achieved). With these

added features, you rarely have to take your eye from the viewfinder.

One caution: Check the LCD panel (or printed calculator dial) of your flash to be sure you are within the working distance for the aperture that the camera selects. Autofocus cameras may readjust the aperture automatically as the camera-to-subject distance changes.

Using Automatic Flash

Automatic flash units require a few more choices and adjustments, but the procedure is pretty straightforward. Here are the steps:

1. Mount the flash on the bracket or hot shoe atop the camera. If the bracket is not electrically connected to the camera, connect the flash to the camera with a PC cord.

2. Set the shutter speed at the fastest available sync speed—1/60 or 1/125 second for most SLR cameras. With automatic cameras, you may have to

switch to the shutter-priority mode for this step.

3. Set the film speed on the flash calculator dial.

4. Turn on the flash unit.

5. If your flash has a zoom head, adjust the zoom head for the lens focal length (wide-angle, normal, telephoto).

6. Focus on the subject and note the subject distance on the lens distance scale.

7. Refer to the calculator dial on the flash (a color-coded dial found on most flashes). According to the subject distance, it recommends mode settings and corresponding apertures. Set the mode you want on the flash, and set the camera aperture corresponding to the subject distance on the lens. As long as you stay within the distance range specified by the flash calculator dial, exposure will be correct at this aperture.

8. Take the picture when the flash "ready" glows.

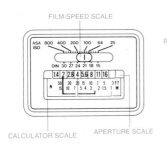

FILM-SPEED SCALE

CALCULATOR SCALE APERTURE SCALE

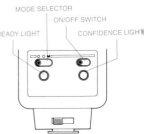

MODE SELECTOR
ON/OFF SWITCH
READY LIGHT CONFIDENCE LIGHT

NO FILL-IN FLASH

FILL-IN FLASH

Fill-In Flash

For outdoor portraits on sunny days, fill-in flash lightens distracting facial shadows created by top-, side-, and backlighting. The fill light supplements the ambient light just enough to brighten dark shadows—usually the flash should be about 1 or 2 stops less bright than the existing light. Fill-in flash is easier to accomplish with low- or medium-speed films.

For many cameras with built-in flash, fill-flash capability is simply a matter of depressing a button—everything else is automatic. Combining matrix metering with TTL flash, the cameras can measure the bright ambient light and release just the right amount of flash fill. Many dedicated flash systems can also provide fill-flash with minimum effort. All you have to do is set the camera to the program mode and turn on the flash and shoot. Autofocus cameras use the camera-to-subject distance to determine the amount of fill light.

You can create the same effect with automatic flash units and automatic (or manual) cameras. Remember though, most 35 mm SLR cameras sync with the flash at speeds of 1/125 or slower. At these speeds and with fast films on sunny days, the apertures needed would be very small (such as $f/22$). To obtain the proper lighting ratio between flash and sunlight more easily, use a slow- or medium-speed film.

Fill-In Flash With Automatic Flash

1. For an SLR camera with a built-in meter, set the shutter speed at the fastest flash sync speed (usually 1/60 or 1/125 second).

2. Set the lens aperture according to a meter reading of the bright background or the ambient light. This controls the exposure for the ambient light.

3. On the flash calculator dial, find the automatic mode that has an aperture 1 stop larger than the lens setting. For example, if the lens is set at $f/8$, choose the mode on the flash for $f/5.6$. Set that mode on the flash. This will create a flash exposure 1 stop less intense than the ambient light. An alternate method is to set the ISO speed on the flash at twice the actual film speed and use the lens opening indicated on the dial.

4. Turn on the flash and take the picture (after the ready light glows).

BOUNCE FLASH

To avoid the harsh light of direct flash, bounce the light from the flash off the ceiling or a wall near your subject. This requires either using a flash with a swivel head or holding the flash off the camera when you take the picture (see "Off-Camera Flash"). The soft, diffused lighting of bounce flash eliminates harsh shadows and is flattering to your subject.

When using color film, bounce light off a white or neutral ceiling or wall. A colored surface will tint the subject with its color. Aim carefully so that the light bounces onto your subject.

Taking a bounce-flash picture with a dedicated/TTL flash is easy. Just aim the flash at the bounce surface and check the sufficient-light indicator in the viewfinder. Bounce exposure with dedicated units is very accurate, because the light is measured at the film plane.

With an automatic unit, bounce exposure is more accurate if you can aim the flash sensor at the subject, not the bounce surface. You can also use the flash in the manual mode and follow the directions below. With any type of flash, remember that correct exposure is based on the combined distance from the flash to the bounce surface to the subject, not the distance from the flash to the subject.

Manual Mode

1. Estimate the distance from the flash to the bounce surface to the subject. Find the aperture that corresponds to this distance on the flash calculator dial.

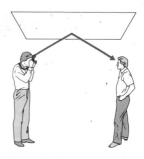

2. Open the lens approximately 2 stops (for example, from $f/8$ to $f/4$) more than the aperture indicated in step 1. This compensates for light absorption by the bounce surface.

Automatic Mode

1. If your flash has a mode selector, set the mode that gives the largest or next-to-largest aperture. If the subject and bounce surface are within a few feet of each other, this may not be necessary.

2. Be sure the light sensor is pointing at your subject—not at the bounce surface. For off-camera flash, use a remote flash sensor you can place on the camera, if available.

3. The total distance from flash to bounce surface to subject should not be more than half the maximum distance indicated on the flash calculator dial, because the bounce surface absorbs light.

4. If your flash has a sufficient light indicator, test, fire the flash using the open flash or test button to be sure that you've chosen the correct mode and f-stop.

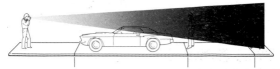

Brightness Fall-Off

The brightness of direct flash decreases quickly with distance. To provide even illumination over a depth greater than 4 feet (1.2 m), use bounce flash.

Glaring Reflections

Shiny paneling, windows, mirrors and eyeglasses produce glaring reflections when struck head-on by flash. Avoid glare from shiny surfaces by standing at an angle to the subject or by using bounce flash.

Finding the Guide Number

If you don't know your flash unit's guide number, use this method. Set the film speed on the flash unit. Look at the calculator dial and multiply any aperture by its corresponding distance (in feet)—that's your guide number in feet for that film speed. Example: With this dial set at ISO 100, $f/8$ corresponds to 15 ft. Guide No. = $8 \times 15 = 120$.

Off-Camera Flash

By holding the flash away from the camera while taking a picture you can add shadows and textures to give a sense of depth and form to your flash pictures.

Off-camera flash also helps avoid reflections from shiny surfaces, such as paneling and windows, directly behind the subject. And it can cast subjects' shadows out of the camera's view where they won't be distracting. Use a long sync cord for freedom of movement when aiming the flash.

If you are using a dedicated camera and flash, be sure to use a dedicated sync cord so that the camera and flash can properly exchange exposure information.

Close-Up Flash

Electronic flash is an excellent light source for close-up photography. It allows you to use small apertures for greater depth of field, and the short duration of the flash freezes movement.

Do not mount the flash on the camera for close-up work—unless the flash head can tilt down, the light may skim over the top of your subject. Instead, use a PC extension cord and hold the flash off-camera so you can aim the flash at the subject. If you're using an automatic unit, set it on automatic and hold it at the minimum distance for the automatic range, as indicated on the flash calculator dial. Also, if you are using a bellows or extension tubes, you will have to give 1 or 2 stops more exposure to compensate

for the light loss. Or you can use the flash in the manual mode and use the table below to set the aperture.

Using a dedicated flash makes close-up work easier because you don't have to calculate any lens extension factors. The dedicated system measures the light passing through the lens, and if you use the correct extension cord, you can place the flash off-camera.

Here are a few other tips on close-up flash: With slide films, bracket. With color-negative films, shoot at the indicated exposure and then at 1 stop wider. For diffused lighting with soft shadows, bounce the flash off a white surface and increase exposure 1 or 2 stops. When in doubt, bracket.

Close-up Flash Table for Extension Tubes, Bellows, and Macro Lenses*

Flash Distance	Reproduction Ratio (Image:Object)								
	1:4			1:2			1:1		
	Guide No.			Guide No.			Guide No.		
	40	60	80	40	60	80	40	60	80
10 in.	f/16	f/22	f/32	f/13.4	f/19	f/27	f/9.5	f/13.4	f/19
15 in.	f/9.5	f/13.4	f/19	f/8	f/11	f/16	f/6.7	f/9.5	f/13.4
20 in.	f/8	f/11	f/16	f/6.7	f/9.6	f/13.4	f/4.8	f/6.7	f/9.5

1. Use a slow- or medium-speed film and preferably a small flash unit.

2. Set the flash on manual.

3. Cover the flash window with two lens tissues or one handkerchief layer.

*In this table, the recommended f-stops are based on a bellows factor to compensate for light loss at different reproduction ratios. Because zoom lenses and supplementary close-up lenses do not have a "bellows factor," f-stops in this table are incorrect for them. Use the table below for zoom lenses and supplementary close-up lenses.

Close-up Flash Table for Zoom and Supplementary Close-up Lenses (Use procedure above)

| Flash Distance | Guide No. | | |
	40	60	80
10 in.	f/19	f/27	f/38
15 in.	f/13.4	f/19	f/27
20 in.	f/9.5	f/13.4	f/19

Stop-Action Flash

The short burst of light from a flash makes it useful for stopping action. By using high-speed film with an automatic flash you can maximize the flash's capabilities, making it especially suitable for action photography. The advantages of high-speed film and automatic flash are: faster recycle time so you don't miss shots waiting for the flash to charge; increased flash range; and sometimes shortened flash duration (as short as 1/50,000 second) to freeze all but the fastest of action. With all flash units, high-speed films allow shooting at smaller apertures.

29

LENSES

An incredible variety of lenses are available for SLR cameras: wide-angle, portrait, telephoto, macro, and on and on. The great advantage of SLR cameras is that they let you see the effect each lens produces. Many photographers pick a lens only with the thought of making the subject look the right size in the picture: thus a wide-angle lens for a mountain range or a telephoto lens for a boat sailing into the sunset.

Such reasoning is fine but incomplete. An equally valid reason for choosing a lens is its effect on apparent perspective. Technically, perspective is influenced only by viewpoint. In practice, however, focal length often appears to change perspective. A telephoto lens can be used to compress apparent distances between things. A wide-angle lens can be used to expand apparent distances between things.

For instance, a wide-angle lens exaggerates perspective in a close-up portrait because it stretches the head from front to back. The nose, very near the lens, seems too large and too close, while the ears, farther from the lens, look too small and too far.

By knowing how to handle different lenses and how they let you alter the image, you can use them more imaginatively. The lens descriptions in this section summarize the advantages and disadvantages of different focal length lenses. The descriptions for a particular focal length also apply to a zoom lens when used at that focal length.

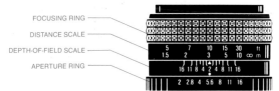

FOCUSING RING

DISTANCE SCALE

DEPTH-OF-FIELD SCALE

APERTURE RING

Lens Flare

Lens flare most often results from internal light reflections when you point the lens at or in the general direction of the sun or other bright light source. Sometimes flare can symbolize bright light, but generally it is a nuisance. You can reduce flare by shading the front of the lens with your hand or with a lens shade. Make sure your hand doesn't block the lens.

30

24 mm LENS

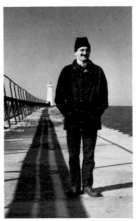

50 mm LENS

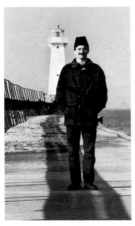

200 mm LENS

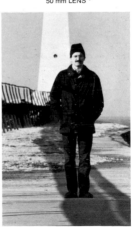

400 mm LENS

Focal Length and Perspective

By adjusting shooting distance and using different focal length lenses, the photographer altered perspective in this photo series. At a close shooting distance, the wide-angle lens exaggerates foreground to background dis-

tance. At a medium shooting distance, the normal lens shows perspective normally. At far shooting distances, the two tele-photo lenses shorten the apparent distance from foreground to background and make the light-house appear large.

Wide-Angle Lenses (15 to 35 mm)

Wide-angle lenses spread their picture-taking arms to embrace a wide view useful for photographing interiors and panoramas. When including near and far subjects, wide-angle lenses appear to stretch distances between them, the stretching being more dramatic the shorter the focal length. A 24 mm lens can seemingly trans- form the gentle curve of a snow-drift into a sweeping mountain ridge. Because wide-angle lenses stretch space, they are quite effective in implying great depth from foreground to background. Wide-angle lenses distort nearby subjects, an effect undesirable in portraits and architectural renderings when you want a realistic impression.

Normal Lenses (40 to 55 mm)

Normal lenses render scenes in a manner that approximates what the eye sees. Distance between objects and relative sizes seem correct. Normal lenses generally have large apertures for existing-light photography and focus close enough for portraits (although they may cause slight perspective exaggeration in head-and-shoulder portraits).

Moderate Telephoto Lenses (85 to 135 mm)

Compact yet possessing relatively large apertures, moderate telephoto lenses are favored for portrait photography. They can frame a face tightly to produce a pleasing portrait. The somewhat restricted depth of field inherent to these lenses can be put to good use in isolating nearby subjects. For subjects within 7 feet (2 metres) of the camera, you can use a wide aperture such as $f/2.8$ to contrast the sharply rendered subject with a pleasantly out-of-focus foreground and background.

Long Telephoto Lenses (200 to 400 mm and longer)

Long telephoto lenses magnify images. Relative to a 50 mm lens, a 200 mm lens magnifies 4X, a 300 mm lens 6X, and a 400 mm lens 8X. Such magnifications make them top choices for sports and wildlife photography and for sunsets to swell the size of the sun.

Use a tripod or a shutter speed faster than 1/focal length of the lens or the image probably will be blurred from camera shake.

Focus carefully as depth of field is very shallow at close and medium distances. A 200 mm lens set at $f/8$ and focused on a subject 30 feet (9 metres) away has a depth of field only 2.5 feet (0.8 metres).

Long telephoto lenses noticeably compress front-to-back distances, dramatically shortening apparent distances between subjects, and making distant subjects appear much closer than they are.

Zoom Lenses

With a zoom lens you can stand still yet change the image size of the subject and the amount of surroundings included. You simply move a collar on the lens that adjusts the focal length.

An 80 to 200 mm zoom lens is well suited to sports photography where the time taken to move closer may cost you a photograph. A 35 to 105 mm zoom lens is good at crowded events like parties so you can zoom from overall shots to portraits.

Zoom lenses usually give sharpest results at mid-range apertures like $f/8$. When zooming from shorter to longer focal lengths, such as from 35 mm to 105 mm, be sure the shutter speed is fast enough to prevent blur from camera shake. Don't let the ease of reframing with a zoom lens prevent you from hunting for the best viewpoint.

Teleconverters

A teleconverter fits between the camera and the lens and doubles or triples the image size. A 2X teleconverter makes a 50 mm lens function as a 100 mm lens and makes a 200 mm lens function as a 400 mm lens. Teleconverters are a simple way of boosting magnification.

A 2X teleconverter cuts the light by 2 stops and a 3X teleconverter cuts it by 3 stops, meaning you have to use a slower shutter speed or larger aperture. The camera meter automatically adjusts for the light loss. For maximum sharpness, use an aperture of $f/4$ or smaller.

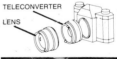

50 mm LENS

50 mm LENS AND 2X TELECONVERTER

FILTERS

Filters are useful for both black-and-white and color photography. In black-and-white photography, they are generally used to prevent differently colored objects from being rendered in too similar gray tones. With filters you can lighten or darken gray tones to tonally separate objects. A filter lightens objects colored similarly to the filter and darkens dissimilarly colored objects. A red filter lightens an apple and darkens grass. A green filter lightens grass and darkens an apple.

In color photography, use filters to shift colors for creative effects or for adjusting color balance. An orange filter inflames a sunset. A blue filter chills a blustery winter day. Conversion and color-correcting filters are useful under tungsten and fluorescent lighting to achieve more normal colors with film not balanced to the light source.

SPECIAL CONSIDERATIONS

Meter accuracy. Deep-colored filters (especially red) may cause inaccurate exposure readings with some built-in meters. To check your meter, take a reading with and then without the filter attached. If the difference between the two readings doesn't match the exposure increase indicated in the table on page 41, any time you use that filter, take a reading and manually adjust the exposure according to the table.

Autofocus. Autofocus systems may also be affected by deep-colored filters, and soft-focus or diffusion filters. To avoid problems, focus manually with the filter in place. See your camera manual for specific filter recommendations or contact the camera manufacturer for any filter limitations.

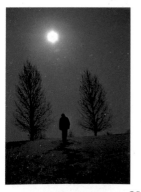

Creative Color When using filters to add color to your pictures, use slide film (unless you do your own enlarging). With negative film, photofinishers strive to print normal colors, not special-effects colors. If your camera meter is accurate when used with filters (see above), simply use the indicated meter reading with the filter attached. Bracket exposures as you may like slightly brighter or darker coloration. This picture was taken at midday through a No. 47 blue filter. A moonlight effect was created by underexposing slide film 1-2 stops.

Star Filter

With this filter you can add
starbursts to any bright point
of light in a scene, including sun-
spangled water. The filter can
be rotated in its mounting to
change the angle of the stars.

Diffusion Filter

A diffusion filter adds a roman-
tic, dreamlike effect by diffusing
highlights and blurring detail.
Try using an aperture in the
range from $f/1.4$ to $f/5.6$, since
smaller apertures may reduce
the diffusion effect.

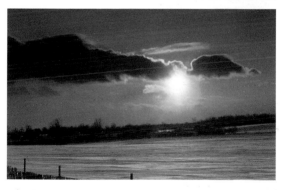

Using Graduated and Split-Field Filters

When using a split-field or grad-
uated filter that has a clear half
determine the exposure before
you attach the filter. If you
determine the exposure after
attaching the filter, the camera
meter may indicate an unwanted
exposure increase. When using
split-field and graduated filters,
you usually want to camouflage
the clear-color border by aligning
it with the horizon or some other
naturally occurring line in the
scene. Otherwise the clear-color
transition line in the filter will be
obvious. Also avoid using a small
aperture with a wide-angle lens
or the clear-color border may
show up as a fuzzy line in the pic-
ture. In this picture the gradu-
ated filter blocked light from the
sky so detail would show in the
snow.

37

WITHOUT POLARIZING FILTER

WITH POLARIZING FILTER

WITHOUT POLARIZING FILTER

WITH POLARIZING FILTER

Polarizing Filters

A polarizing filter can darken a blue sky, remove reflections from windows and water, increase color saturation, and even penetrate atmospheric haze. The effects vary dependent on where you stand, the direction of the light, and how much you rotate the filter.

Sound complicated? It isn't, because with an SLR camera you can see the effects in the viewfinder as you rotate the polarizing filter. Before taking the picture, rotate the filter for maximum effect. It darkens

blue sky at 90° angle to the sun (point your shoulder at the sun and the sky in front of you will be darkened; if the sun is overhead, sky near the horizon will be darkened). To remove reflections, stand at an angle approximately 35° to the subject.

Manual-focus SLR cameras use "linear" polarizing filters; some auto-exposure and most autofocus cameras require "circular" polarizers for correct exposure. Check your camera manual to see which type your camera uses.

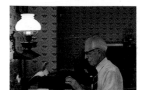

DAYLIGHT FILM: NO FILTER

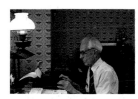

DAYLIGHT FILM: 80A FILTER

Conversion Filters

Color conversion filters 80A and 85B are among those used when color film is improperly matched to the light source. For instance, in tungsten light, daylight film gives yellowish colors. With daylight film, the blue 80A filter counteracts the excessive yellow of tungsten light and gives normally colored pictures.

In daylight, tungsten film yields blue colors. The yellow 85B filter provides the correct colors for tungsten films used in daylight.

Conversion Filters for Color Films

Type of Color Film	Light Source		
	Daylight	Tungsten (3200 K)	Photolamp (3400 K)
Daylight	No Filter	No. 80A +2 stops	No. 80B +1⅔ stops
Tungsten*	No. 858 +⅔ stop	No filter	No. 81A +⅓ stop
Photolamp	No. 85 +⅔ stop	No. 82A +⅓ stop	No filter

*KODAK EKTACHROME 160 Film (Tungsten) balanced for 3200 K

Fluorescent Filtration

Often deficient in red light, fluorescent lighting may give pictures a greenish cast. The easiest way to get better color is to use KODAK GOLD 400 Film or KODAK ROYAL GOLD 1000 Film. Specially sensitized, both films give acceptable results (without filtration) under fluorescent lighting. With other daylight films, especially slide film, use an FLD filter to reduce the greenishness. Although correction is not perfect, colors will be better.

DAYLIGHT FILM: FLD FILTER

DAYLIGHT SLIDE FILM: NO FILTER

NO FILTER

81B FILTER

Light-Balancing Filters

To obtain conventional color balance at different times of day when using slide film, try the filtration recommended in the chart on the opposite page. Since conditions vary, these filters will give good but not perfect results. Here a yellowish 81B filter reduces the bluishness from an overcast day.

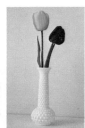

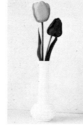

NO FILTER

No. 25 RED FILTER

Filtering Black-and-White Film

In black-and-white pictures, color filters lighten tones from subjects colored similarly to the filter and darken tones of subjects colored dissimilarly. The photos above show how a No. 25 red filter lightens the red tulip.

NO FILTER

No. 8
YELLOW FILTER

No. 21
ORANGE FILTER

No. 25
RED FILTER

Darkening Blue Sky

In black-and-white photography, you can increasingly darken a blue sky and stress the clouds with the filters used for the above pictures. Color filters have little effect on an overcast sky.

Light-Balancing Filters for Daylight Color Slide Film

Daylight Source	Filter	Exposure Increase in Stops
Sunrise, sunset	80B 80C	$1\frac{2}{3}$ 1
2 hours after sunrise or before sunset	80D	$\frac{1}{3}$
Mean noon sunlight	None	
Overcast sky, Open shade	81B or 81C	$\frac{1}{3}$

Filter Recommendations for Black-and-White Films in Daylight

Subject	Effect Desired	Suggested Filter	Exposure increase in stops
Blue sky	Lightened	No. 47 Blue	$2\frac{2}{3}$
	Natural	No. 8 Yellow	1
	Darkened	No. 15 Deep Yellow No. 21 Orange Polarizing filter	$1\frac{1}{3}$ $2\frac{1}{3}$ $1\frac{1}{3}$
	Greatly darkened	No. 25 Red	3
	Almost black	No. 29 Deep Red	4
Marine scenes when sky is blue Sunsets	Natural	No. 8 Yellow	1
	Water dark	No. 15 Deep Yellow	$1\frac{1}{3}$
	Natural	None or No. 8 Yellow	1
	Increased contrast	No. 15 Deep Yellow No. 25 Red	$1\frac{1}{3}$ 3
Distant landscapes	Increased haze effect	No. 47 Blue	$2\frac{2}{3}$
	Natural	No. 8 Yellow	1
	Haze reduction	No. 15 Deep Yellow No. 21 Orange Polarizing filter	$1\frac{1}{3}$ 2 $1\frac{1}{3}$
	Greater haze reduction	No. 25 Red No. 29 Deep Red	3 4
Foliage	Natural	No. 8 Yellow No. 11 Yellowish-Green	1 2
	Light	No. 58 Green	$2\frac{2}{3}$
Outdoor portraits against sky	Natural	No. 11 Yellowish-Green No. 8 Yellow Polarizing filter	2 1 $1\frac{1}{3}$
Architectural stone, wood, sand, snow when sunlit or under blue sky	Natural	No. 8 Yellow	1
	Enhanced texture rendering	No. 15 Deep Yellow or No. 25 Red	$1\frac{1}{3}$ 3

LIGHTING

From dawn to dusk the light changes and, in turn, the appearance of anything it strikes changes. The light changes in three important ways: intensity, color, and direction. At sunrise, the soft, yellowish frontlighting from the sun may flatter crumbling castle ruins as a romantic symbol of legends, while at midmorning the harsh, almost colorless sidelighting from the sun will pick out every little defect and depict the same ruins as a symbol of neglect. Generally, early or late day sun is the most versatile. When fairly low in the sky, the sun can be used as a frontlight, sidelight, or backlight simply by changing viewpoint. In addition, the warm color of light from the low sun may be more pleasing than the nearly colorless light of midday.

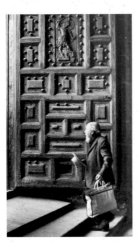

Sidelighting

Sidelighting adds depth, dimension, and texture to a scene. The elongated shadows from sidelighting clarify the spatial relationships between objects and emphasize their form and mass. Adjacent lighted and shaded areas give bold contrast. To retain shadow detail, generally, you must open up ½ to 1 stop from the meter indication.

Frontlighting

Frontlighting highlights details within a scene and provides good color saturation. Although head-on lighting tends to flatten a scene into one dimension, it is especially easy to work with in landscapes. Avoid harsh frontlighting in portraits because subjects squint in the blast of light.

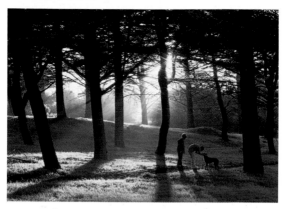

Backlighting

Backlighting, combined with an appropriate subject, sometimes makes an otherwise dull picture exciting. It can be used to reduce multitudinous picture elements into a simple silhouette or to add a glowing rim around a face. In landscapes, it exaggerates depth by creating elongated shadows that stretch from background to foreground.

Diffused Lighting

Diffused light spreads evenly and gently over a subject, sometimes giving slight modeling of form and softening of texture. It allows for intense color saturation and is excellent for photographing people and nature. Contrast is at its lowest under diffused light, and delicate hues never found under bright light now appear.

LINE

Lines are present in nearly all scenes, but dominate only in a few through a whimsy of lighting, viewpoint, or subject arrangement. Use lines whenever possible. They are irresistible paths that seduce the eye. Undulating lines, curved lines, straight lines all lead somewhere and take the eye along with them. Bold, straight lines, cutting diagonally, invigorate images. Wavy, horizontal lines impart tranquility.

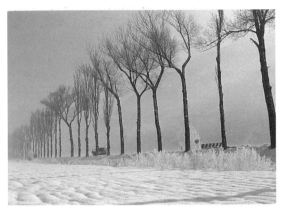

Leading Lines Add Depth

A road, a fence, a row of trees, or any other strong line enhances the feeling of depth in a photograph.

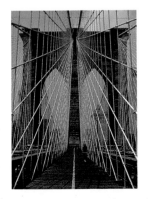

Diagonal Lines Are Dynamic

Diagonal lines impart a feeling of motion and vitality more than horizontal or vertical lines. If you want to instill such vigor, you can often find a viewpoint that will yield diagonal lines.

SHAPE

The most important element in identifying an object is shape. A simple shape consists of only an outline. Take away color, take away texture, take away form, and you can still identify many a subject by its shape. By accenting shape, you can make bold, graphic images. Harsh frontlighting and back-lighting work best to accent shape. Harsh frontlighting strips away texture and washes out subtle hues, leaving shape and bold color to dominate. Backlighting lets you create silhouettes that hide texture, color, and form.

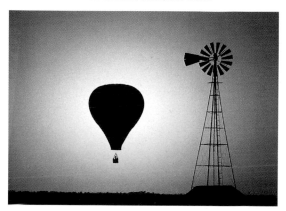

Silhouette for Shape

By backlighting a subject against the sky or other bright background, you can create a silhouette. The lack of detail in silhouette makes it akin to a Rorschach inkblot that challenges the mind to imagine what isn't seen. To make a silhouette, take an exposure reading from the bright background and underexpose 1 to 2 stops. Exclude the sun from the view-finder when metering.

One-Sided View Stresses Shape ▷

By showing only one side of the subject you minimize form and emphasize shape. When a second side shows, the subject takes on some form and depth.

45

TEXTURE

Texture defines the surface of an object. Smooth, rough, slippery, abrasive are commonly encountered textures. By showing the texture of an object, you strengthen the realism of the photograph, especially if the texture of the object is well known. The sight of texture, even in a photograph, evokes memories of how the object felt. In a photograph of an ice cream cone, for example, the hand cannot feel the cone's texture in the photograph but the sight of the cone calls up memories of how the cone previously felt in your hand. Sometimes texture should be suppressed because it counters what you are trying to say. For instance, it might be appropriate to stress facial texture in a portrait of a rugged mountain climber but inappropriate for a beauty queen.

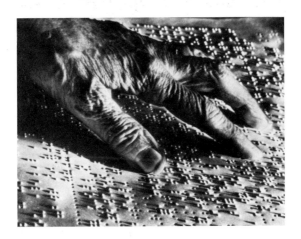

Sidelighting Stresses Texture

Sidelighting stresses texture. Frontlighting hides it. Sidelighting skims across surfaces throwing shadows that sculpt the texture. By increasing or decreasing the degree of sidelighting or by using a reflector to lighten shadows, you can weaken or strengthen the relief of the texture as you see fit. Harsh sidelighting, as from the bright sun, works best for small, granular textures like sand. For larger textures that might be obscured by shadows, like the surface of an oak tree or a cliff, a weaker or even diffused sidelighting works well.

FORM

Form refers to the three-dimensionality of an object. It indicates an object's sphericality or cubicity. Form is the cylindrical trunk of a tree, it is the curve and recurve of a horse's flank, it is the protrusion of your nose, the roundness of your cheeks, the recesses of your eye sockets. Revealing form in photographs makes them more lifelike. It is one of the few ways you can transfer from reality to rendering the feeling of depth and dimension. The challenge resides in successfully imparting the three dimensions of form to the two dimensions of a photograph. Viewpoint and direction of light are the two most important factors in revealing form.

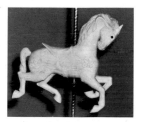

FRONTLIGHTING

Viewpoint △

To show the form of box-like structures, such as buildings, choose a viewpoint that reveals two sides of the structure. For rounded subjects, use a viewpoint that shows the interesting features.

Direction of Light ▷

The best lighting to reveal form is a diffused or weak sidelighting because it yields a range of highlights, midtones, and shadows that readily define form. In these three pictures of a carousel horse, you can see how the diffused sidelighting from a north window best outlines the features of the horse. It alone gives a gradation from highlights to midtones to shadows.

Harsh sidelighting also reveals form but dense shadows hide subtleties of form. Frontlighting creates uniform tonal range that disguises form but shows the overall shape of the horse.

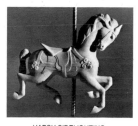

HARSH SIDELIGHTING

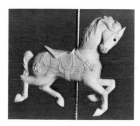

DIFFUSE SIDELIGHTING

CREATIVE COLOR

Colors blaze into our minds. Red seethes. Blue chills. Yellow warms. Color association sometimes becomes synonymous with a subject. Rose-red, sky-blue, grass-green are common associations, even though these things are often differently colored. Intense, sensual, realistic—color rouses, calms, saddens. Use it when you find it. For the most part you can only work with the colors before you. You do, however, have some control. With filters, you can color the whole scene the color of the filter. With natural light, you can pick the time and place, as both influence the color of light: golden at sunset, bluish at twilight and in the shade. With artificial light, you can use daylight film to render tungsten-lighted scenes yellowish (sometimes effective for an antique look).

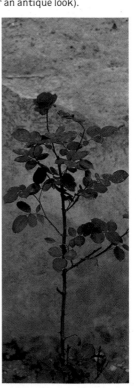

Monochromatic Color △
A single color washed across a picture creates a very distinctive impression. Brash and stimulating if the color is bold; melancholic if the color is quiet. Filters, foggy days, or close-ups, as of this fish line, let you use the monochromatic approach.

Color Highlights ▷
A brightly colored subject or one contrasting in color with the background stands out in a photograph. Although rendered small, the rose nonetheless grabs attention because it counterbalances the drab wall.

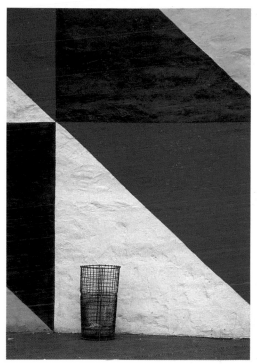

Design with Color △

Choose viewpoint and framing to create bold, graphic effects. Search for strong lines and shapes as in this picture. Small areas of bright and warm colors like red easily balance larger areas of dark and cold colors like purple. To stress design, suppress clues of shape and detail that identify a subject.

Contrasting Colors Shout ▷

Bright combinations of contrasting colors like yellow and blue and red quickly call attention to themselves. As the eye flits from one color to the next, the colors

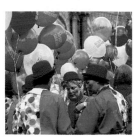

themselves seem to tug at each other. Unify contrasting colors by arranging them in patterns or by balancing the colors against a muted background.

COMPOSITION

Composition, the arrangement of subjects within the photograph, can make or break a picture. Composition requires a willingness to bend in two places: mind and knees. What appears to be a chaotic landscape from one point of view might, from a few steps away, fall into an intriguing geometric pattern. Consider a low angle, a high angle, a closer position, a more distant position. Contemplate the subject from all angles. Stoop down and look at it through the viewfinder. Climb up and study it. Walk around it to view it from the sides, back, and front. Then decide from where to photograph it.

SPECIAL CONSIDERATIONS

Subject. Do you have a clearly defined subject? Many pictures suffer because it's not clear what the subject is. Too many competing subjects dilute a picture.

Distance. Are you close enough? Many (but not all) subjects benefit when they fill the frame, thus presenting details for scrutiny.

Format. Should you use a vertical or horizontal format?

Generally (but not always), a vertical format befits tall subjects, and a horizontal format befits wide subjects. But don't hesitate to frame a horizontal scene vertically (and vice versa) if it looks better.

Background. Is the background subdued? It's easy to overlook a distracting background in the viewfinder, but when looking at the actual picture there's no way to overlook it.

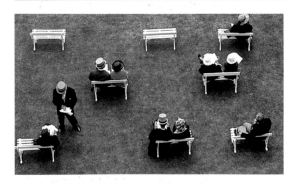

Patterns

Patterns attract and hold the eye. Use them: The repetition of form or shape unifies a photograph. The surprise of an unexpected break in a pattern delights the eye.

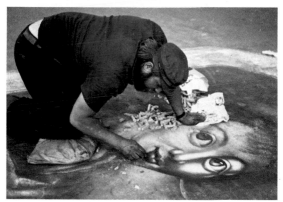

Viewpoint △

Try different angles. A high viewpoint gives a very different picture than a low viewpoint, as does a front view from a side or back view. Here, only a high viewpoint clearly shows both the artist and his work.

Control the Background ▽

The background should showcase the subject, not distract from it. Use the depth-of-field preview button to check for distracting features in the background at the preselected aperture. A plain, unobtrusive background often works best. A large aperture and a carefully chosen viewpoint can help you get a plain background. When showing the background sharply, make sure it's appropriate for the subject.

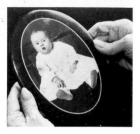

The Details

We tend to show the whole and ignore the part. Often a detail speaks more forcefully than the overall view. Look for telling details. In this picture, the juxtaposition of adult hands and an infant's picture compels attention.

Simplify

Simple pictures work. They are clear, concise, and easily understood. Simplify by excluding unnecessary subjects, by using a plain background, by filling the frame, and by composing clearly to present the subject unambiguously.

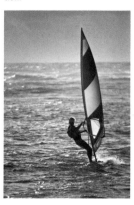

Attractive Subject Position

Subjects positioned off-center often appeal more than centered subjects. If the board sailor were positioned dead center, the picture would seem lifeless, the symmetry meaningless. Positioned off-center, he breaks up the symmetry, freeing the eye to explore the scene.

Eye-Catching Contrast

Contrast makes a subject pop out from the background. Sunlight highlights the subject against a shaded background. Color contrast also separates a subject from the background.

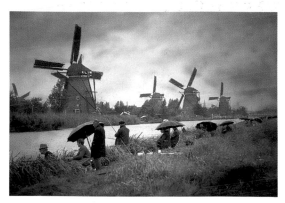

Dynamic Diagonals △
Diagonal composition is more dynamic than vertical or horizontal. Diagonals imply motion because they seem to be rising or falling, or moving toward or away from the viewer.

Lighting ▽
Always keep an eye out for unusual lighting: a shaft of sunlight spotlighting a horse, a pattern of light and shadows from a snow fence. Unusual lighting can animate an otherwise lacklustre picture.

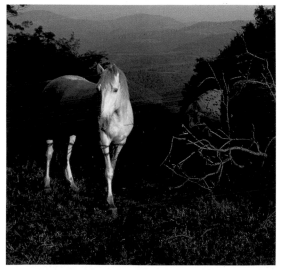

EXISTING LIGHT

Forget the tripods and flash guns. Instead, grab a few rolls of high-speed film and get ready to handhold your camera for shots you never thought possible in dim light. Circuses, ice shows, night skylines, sporting events, weddings, and more become a breeze to photograph. Unlike sunny-day pictures, existing-light photographs arouse a mood of mystery and suspense that grows as the light dies. They preserve the realism of a scene that wilts under a harsh light of a flash. Many subjects, such as city lights at twilight, are easy to photograph because a variety of exposures look good.

SPECIAL CONSIDERATIONS

Color balance. Artificial lighting can give color casts to daylight color film. Use filters, match film to light source, or use fast color negative film—often it can be color corrected when printed.

Doubling film speed. To obtain a faster shutter speed or smaller aperture, you can double the speed of KODAK EKTACHROME Films (color) and KODAK TRI-X Pan or T-MAX Professional Films (black-and-white). See page 15 for details.

Reciprocity effect. At long exposures, a film's response to light may change. In existing light photography adjustment for color shifts may not be critical but exposure should be adjusted as in the table on the opposite page.

Use Fast Color Neg Film

KODAK GOLD 400 and KODAK ROYAL GOLD 1000 Films simplify photography in existing light. They let you handhold the camera in dim light—even when using telephoto lenses. They have wide exposure latitude to make good pictures under tricky lighting. And they give good color under tungsten and fluorescent lighting without filtration, although proper filtration is suggested for optimum results.

Brace Yourself

If using a slow shutter speed, you risk blur from camera movement. Brace yourself against a wall or railing and you might have luck with shutter speeds as slow as ¼ second. Focus carefully when in dim light.

Exposure and Filter Corrections for Reciprocity Effect

KODAK FILM	Exposure Time (seconds)	
	1 sec	10 sec
ROYAL GOLD 25 ROYAL GOLD 100 ROYAL GOLD 200 ROYAL GOLD 400 ROYAL GOLD 1000 GOLD 100 GOLD 200 GOLD 400	no correction needed	
KODACHROME 25	+1/2 stop, no filter	NR
KODACHROME 64	+1 stop, CC10R	NR
KODACHROME 200	NR	
EKTACHROME 100 PLUS	+1/3 stop, CC05R	NR
EKTACHROME 200	+1/2 stop, CC05M	NR
EKTACHROME 400X	+1/3 stop, CC05R	+1/2 stop, CC10R
PLUS-X, TRI-X	+1 stop*	+2 stops†
TECHNICAL PAN	no correction needed*	+1/2 stop*
T-MAX 100 T-MAX 400	+1/3 stop	+1/2 stop

NR—Not recommended for critical use as colors shift, although will often be suitable for landscape photography depending on your tastes. Increase exposure 1/2 to 1 stop and bracket.
*Reduce development of film by 10%.
†Reduce development of film by 20%.

Watch Your Exposure

Existing-light exposures can be tricky. If possible, take a close-up meter reading of the main subject to determine exposure. Some cameras have a spot-metering feature that reads a small area of a scene—very helpful in these situations. Otherwise, bracket around either the exposure indicated by your meter or the exposure suggested in the table on page 57.

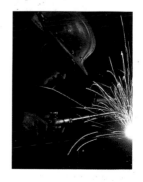

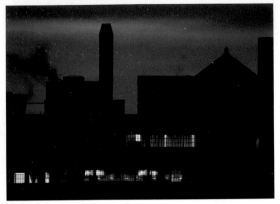

Twilight Scenes

Twilight scenes are moody. Skylines, farm houses, and even roads take on a shadowy existence as night encroaches.

Shapes disappearing into the darkening blue of night are counterpointed by window lights.

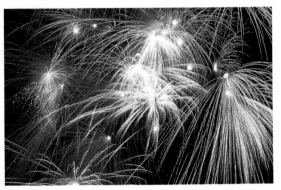

Fireworks

To photograph fireworks, set the shutter on B to allow a time exposure, and aperture to $f/8$ for ISO 64 film, $f/11$ for ISO 200 film, $f/16$ for ISO 400–1000 films. For sharp fireworks bursts, use a tripod and hold the shutter open with a cable release until several bursts of fireworks are recorded. Without touching the lens, cover it with your hand or black card between bursts. If without a tripod, use a shutter speed of 1/30 second and $f/4$ for ISO 200 film or 1/60 second and $f/4$ for a 400–1000-speed film. Take the picture when several bursts occur simultaneously.

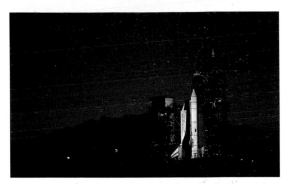

Autofocus in Existing Light

If your autofocus camera has difficulty focusing in dim light, you may still find a small patch of brightness in the scene that will activate the focus. Look for an area that is the same distance as your main subject, and use your camera's focus-lock feature to hold focus while you reframe and shoot. When all else fails, focus manually or use flash.

Existing-Light Exposures for Night and Indoor Events

Subject	ISO 64-100	ISO 125-200	ISO 320-400	ISO 800-1000
Brightly lighted streets	1/30, f/2	1/30, f/2.8	1/60, f/2.8	1/60, f/4
Neon signs	1/30, f/4	1/60, f/4	1/125, f/4	1/125, f/5.6
Floodlighted buildings, monuments	1, f/4	½, f/4	1/15, f/2	1/30, f/2
Skyline—distant view of lighted buildings	4, f/2.8	1, f/2	1, f/2.8	1, f/4
Skyline—10 minutes after sunset	1/30, f/4	1/60, f/4	1/60, f/5.6	1/125, f/5.6
Fairs, amusement parks	1/15, f/2	1/30, f/2	1/30, f/2.8	1/60, f/2.8
Fireworks—time exposure	f/8	f/11	f/16	f/22
Burning buildings, campfires, bonfires	1/30, f/2.8	1/30, f/4	1/60, f/4	1/60, f/5.6
Night outdoor sports	1/30, f/2.8	1/60, f/2.8	1/125, f/2.8	1/250, f/2.8
Basketball, hockey	1/30, f/2	1/60, f/2	1/125, f/2	1/125, f/2.8
Stage shows—Average Bright	1/30, f/2 1/60, f/2.8	1/30, f/2.8 1/60, f/4	1/60, f/2.8 1/125, f/4	1/125, f/2.8 1/250, f/4
Circuses, Ice Shows Floodlighted acts Spotlighted acts	1/30, f/2 1/60, f/2.8	1/30, f/2.8 1/125, f/2.8	1/60, f/2.8 1/250, f/2.8	1/125, f/2.8 1/250, f/4

PEOPLE

Sooner or later we all photograph somebody. Whether being photographed casually or formally, many people stiffen when in front of the camera. Try to relax them and divert their attention from the camera with casual conversation: tell them they look fine and will photograph well. Before you start, let them know you'll be taking several pictures so you can catch that telling nuance—the raised eyebrow, the parted lips. Be patient, be good-natured. Rapport between photographer and subject often determines the outcome of the photograph.

You can use three basic styles to photograph people: 1. The formal portrait in which you orchestrate pose, lighting, props, and expression to characterize the person. 2. The informal portrait in which you use pose, surroundings, and clothes to portray the person casually. 3. The candid in which the photographer acts as a detached and preferably unnoticed observer to show a person in natural and revealing behavior.

Choose the appropriate style. At a picnic, for instance, a candid shot may be more befitting than a formal portrait.

LIGHTING

Choose the lighting carefully. The most gentle and flattering light is diffused light. It is also the easiest to use.

Diffused light can be found outdoors on hazy or overcast days, in open shade, and indoors near windows admitting indirect light (a north window, for example). It can also be created with bounce flash.

Direct frontlighting from the sun causes squinting. When the sun is near the horizon, however, frontlighting may be soft and warm enough to caress the face. Avoid the toplighting of midday as it casts ugly nose and lip shadows down the face.

Diffused Lighting
Diffused light treats the face kindly, minimizing cosmetic flaws. Light from a cloudy day was used for this picture.

Backlighting

Backlighting adds a nice rim-light to the hair and leaves the face in diffused light. With backlighting, you must either increase exposure or add light to the shaded face.

For best results, take a close-up-meter reading of the face, or use a spot meter if your camera has one to read just the skin tones. Another method is to manually increase exposure by 1½ to 2 stops. A white cardboard reflector or fill-in flash can lighten the face while holding detail in the background.

Sidelighting

The interplay between light and dark on a face can create a bold picture. You can use either a flash unit or sunlight to create sidelighting.

To show detail in the dark area requires up to a 1-stop increase in exposure over a general reading. You can also add light to the shadows with a reflector fill-in flash. Here no light was added to shadows to preserve the dramatic lighting.

Avoid Perspective Exaggeration

Unless you want to carica-ture your subject, don't use a wide-angle lens for head-and-shoulders portraiture. A 50 mm lens can be used but a lens in the 80 to 135 mm range is the best choice.

PORTRAIT TAKEN WITH
24 mm LENS

NO FILTER

81B FILTER

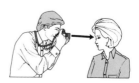

Filter for Shade

Flesh tones of portraits taken in open shade or on overcast days on slide film often have a light blue tinge from the sky. To eliminate that bluish tinge, use a yellowish 81A or 81B (used here) filter. No filtration is needed with color negative film.

Camera Height ▷

For a head-and-shoulders portrait, a camera at the height of the subject's nose gives a pleasant perspective. For a full-figure shot, center the lens with the subject's upper chest.

Portraits—Vary the Poses

When taking portraits try several different poses. As you work, the best pose often arises naturally. Try to stress an attractive feature of your subject, be it big, round eyes, smooth complexion, or pleasing expression.

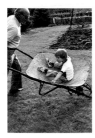

Candids

Candid photographs seem spontaneous and uninhibited, showing the true nature of the subjects. Upon spotting your camera, subjects may become self-conscious. However, if you keep your camera out in the open, they'll often forget about you and act normal.

Direct Eye Contact

Eyes gazing from the photograph attract the viewer. If the eyes are rendered sharply, often the rest of the portrait is perceived as sharp even if slightly out of focus.

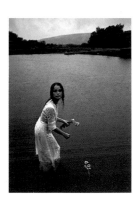

Environmental Portraits

Choose a location familiar and comfortable to the subject. The outdoors for an outdoor person, the workshop for a woodworker, or any other natural setting. Choose a simple background and avoid complicated setups that detract from the subject.

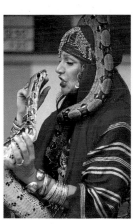

Full Figure? Head-and-Shoulders?

Usually there's no need to show a person full length. Most people are attracted to the face, so concentrate on the upper body. Don't crop a figure right at the elbows or knees. Crop midway above or below joints to avoid an amputated look.

Corrective Portrait Techniques

To make a portrait that flatters the person, you can often vary lighting or camera angle to improve facial appearance. In this comparison, a double chin (near right) was hidden by having the subject tilt his chin upward (far right).

Difficulty	Suggested Treatment
Prominent forehead	Tilt chin upward Lower camera position
Long nose	Tilt chin upward Face directly toward lens Avoid toplighting Lower camera position
Narrow chin	Tilt chin upward
Baldness	Lower camera position Screen to shield top of head Blend top of head with background tone
Broad face	Raise camera position Turn face to three-quarter view
Wrinkled face	Use diffuse lighting Use three-quarter pose
Double chin	Tilt chin upward Use high camera position
Facial defects	Keep on shadow side
Prominent ears	Turn head to hide far ear Keep near ear in shadow Consider profile view

CHILDREN

Restless, roaming creatures whose attention fades the moment caught, children can frustrate even a patient photographer. Don't expect children to adapt to you. You adapt to them. Initially a child will be attracted to a camera, and might mug to it for a few minutes before losing interest and acting natural again.

When possible, avoid using a flash unit because you'll call attention to yourself each time it flashes. Candid photography is best. Portraits present a good likeness, but can't capture the impish, moody, and often headstrong behavior of most children. Photograph a child at a daily activity—playing, reading, pretending.

Playgrounds

Children are easy to photograph when playing, leaving you to work without worry of creating spontaneity. Consider using high-speed film to achieve fast shutter speeds that slow down children's darting and leaping.

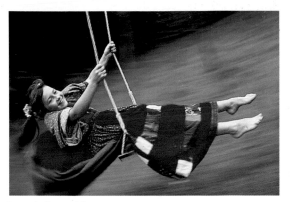

Dynamic Composition

Complement little dynamos with dynamic composition. Kneel down and use a low viewpoint to show a child at the peak of an arc on a swing, perched atop a seesaw, or running by. Panning, subject blur, and other action techniques are appropriate for playing children.

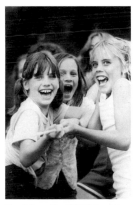

Shoot from the Child's Level

Angling the camera down toward a child preserves the adult viewpoint but may not make a good photograph. By shooting from the child's level, you'll present a more interesting and pleasing view.

Celebrations

Birthday parties, the opening of Christmas gifts, and other events can be captured easily using flash. Absorbed in their activity, the children will ignore the flash. Make a picture story from preparations to the eager ripping open of gifts to the cleanup.

ACTION

Leaping, sprinting, cycling, soaring. Motion whirls, swirls, and twirls about you. You can photograph it with two techniques: stop action or blur. Stop action uses fast shutter speeds to show subjects needle-sharp. With stop action, the sense of movement is often lost, but power, form, strength, skill, and determination are stressed. Blur, above all else, conveys the sense of motion. It heightens the rush of race cars, the fluidity of pole vaulters. Blur techniques use slow shutter speeds with the camera either panned or held steady.

Whether it's kids at play or professionals at work, whether you're using stop-action or blur techniques, the action will snap past your camera faster than a Vegas dealer firing out cards. Know your game. Be ready. Anticipate.

SPECIAL CONSIDERATIONS

Obtaining a large image.
For a large image, move in close or use a telephoto lens. A zoom lens lets you change image size without changing your position.

Preparation. Set the exposure before the action starts. Prefocus on the spot where you anticipate action.

With enough depth of field you won't have to change focus as long as the action is within a certain range. Use the scale on the lens barrel or the depth-of-field preview button to determine the zone of sharpness.

Shutter speed. Use fast shutter speeds to stop action, slow shutter speeds to blur action. With an auto-exposure camera, select the shutter-priority mode so you can control the speed.

Save time. Reload during a break in the action. Reload even if you must waste a few frames of film so you won't have to reload during the action.

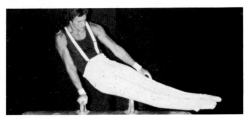

Action-Stopping Flash
Many flash units give you action-stopping capability greater than even the fastest shutter speed on your camera.

Used close or in conjunction with a high-speed film, you may get bursts of flash as short or shorter than 1/30,000 second.

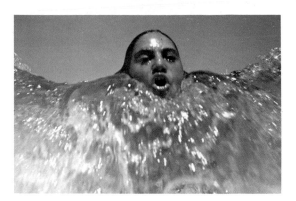

Stopping Action with Slow Shutter Speeds

To stop motion with a slow shutter speed (1/30–1/60 second), move back from the subject and shoot head on. A subject moving directly toward or away from the camera shows the least apparent motion. Also look for the peak of action, that brief hanging moment when motion seems to cease—a soccer goalie stretched in midair, a running back reversing direction.

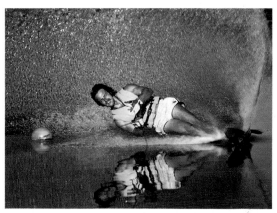

Stopping Action with Fast Shutter Speeds

To stop motion, the obvious advice is to use the fastest shutter speed possible. However, sometimes that's not fast enough or you might not think it is fast enough. The chart on page 69 shows what shutter speeds will stop motion based on speed, direction, distance, and focal length of the lens. On all but the brightest days, use high-speed film.

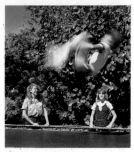

Motion Blur: Camera Steady

Holding the camera steady and using a slow shutter speed blurs a moving subject but leaves sharp those unmoving parts of the scene. Use a tripod for shutter speeds slower than 1/lens focal length, unless you want a blurred background also. The slower the shutter speed the greater the blur. Shutter speed here was ⅛ second.

Panning

Panning means taking a picture at a slow shutter speed as you track the subject with the camera. It yields a fairly sharp subject and a blurred background.

Panned pictures look best when the subject almost fills the frame, a condition most easily met with a telephoto lens. To get slow shutter speeds, use a slow- or medium-speed film in bright light. A polarizing filter blocks enough light to let you use a shutter speed one stop slower.

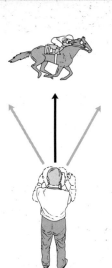

Start with a shutter speed approximating the reciprocal of the speed of the subject in miles per hour (example, 1/30 second for 30 mph). Try faster and slower shutter speeds, too, as results are somewhat unpredictable. Here's the procedure:

1. Set the exposure ahead of time.

2. Prefocus on the spot where the subject will pass. With an autofocus camera, select the servo focus mode so the camera will focus on the moving subject.

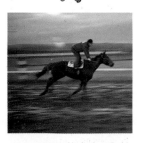

3. Track the subject in the viewfinder; shoot without stopping your swing as the subject crosses in front of you, and follow through with the panning motion.

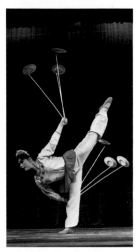

Indoor and Night Outdoor Events

High-speed film is almost a must, even if you can get close enough to the action to use flash. Many high-speed films, such as the KODAK EKTACHROME Films, KODAK TRI-X Pan Film, and KODAK T-MAX Films, can be doubled in speed. With KODAK ROYAL GOLD 1000 Film, you'll usually obtain shutter speeds fast enough to give sharp results with telephoto lenses.

You can steady a telephoto lens by resting it on a railing, on a bean bag, or by mounting it on a tripod.

With color film, try to match the film to the light source for more normal color rendition. Call the stadium ahead of time to determine the type of lighting used. If you can't use the correct color film or color correcting filters, use black-and-white film or color negative film, which can be color corrected during the printing stage.

Everyday Motion

The world's on the move. Car-chasing dogs, wind-tossed leaves, breaking waves and billowing sails do not attract much attention. Yet, a good motion shot of them almost always catches the eye. For this shot the camera was mounted on a tripod and a shutter speed of ⅛ second was used.

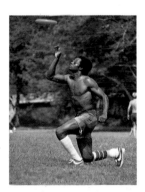

The Telling Pose

Caught in a moment of intense concentration, a flying disc player poises beneath the disc, timing its fall. Familiarity with a sport will help you anticipate the telling moment.

COMPOSITION FOR ACTION

Composition is just as important for action photography as it is for less mobile subjects. With action photography, you must often compose within a split second or risk losing the picture. However, photographs decided in a split second don't always work. To increase your chances of getting a good picture, take as many pictures as you can. Shown below are a few ways of conveying the vigor and motion of action.

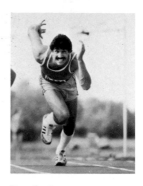

Stressing Power
Use low-angle shots. They exaggerate size, power, and vigor.

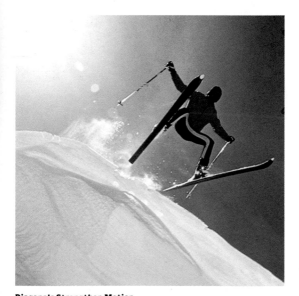

Diagonals Strengthen Motion
Diagonal composition suggests imbalance and consequently motion. When possible, favor diagonal compositions for action pictures over horizontal and vertical compositions, which imply stability.

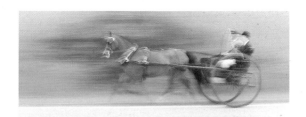

Receiving Area

To preserve the feeling of continuing motion, generally it's best to leave some open space to receive the moving subject. Here the photographer panned the camera using a shutter speed of ¼ second.

Motion-Stopping Shutter Speeds

Based on a normal focal length lens*
(50 mm lens for 35 mm photography)

Speed	Type of Motion	Distance from Camera		Direction of Motion		
				OR	OR	OR
Mi/Hr (Km/Hr)		Ft	M	↔	↘	↕
5 (8)	Strollers Handwork	12	4	1/500	1/250	1/125
		25	8	1/250	1/125	1/60
		50	16	1/125	1/60	1/30
		100	33	1/60	1/30	1/15
10 (16)	Joggers Horses walking Children playing	12	4	1/1000	1/500	1/250
		25	8	1/500	1/250	1/125
		50	16	1/250	1/125	1/60
		100	33	1/125	1/60	1/30
25 (40)	Horses running Sprinters Sports	12	4	1/2000	1/1000	1/500
		25	8	1/1000	1/500	1/250
		50	16	1/500	1/250	1/125
		100	33	1/250	1/125	1/60
50 (80)	Racehorses running Fast-moving vehicles	25	8	1/2000	1/1000	1/500
		50	16	1/1000	1/500	1/250
		100	33	1/500	1/250	1/125
		200	66	1/250	1/125	1/60
100 (160)	Very fast-moving vehicles	25	8	—	1/2000	1/1000
		50	16	1/2000	1/1000	1/500
		100	33	1/1000	1/500	1/250
		200	66	1/500	1/250	1/125

*For each doubling of the focal length you must double the shutter speed. Example: 1/125 second with a 50 mm lens becomes 1/250 second with a 100 mm lens and 1/500 second with a 200 mm lens.

LANDSCAPE

Landscapes aren't restricted to land but can include sky, water, and buildings. Landscapes can be rural or urban, natural or manmade. Perhaps the biggest difficulty in landscape photography is overcoming the belief that landscapes are synonymous with panoramas. They aren't. Wide-angle panoramas too often result in a cluttered mishmash that shows everything yet reveals nothing. Many good landscape photographs succeed because of a narrower viewpoint. They depict but a lone hilltop oak or a solitary cabin. A telephoto lens helps in narrowing the view.

SPECIAL CONSIDERATIONS

Composition. Five important points to consider are:

1. Choose one dominant subject.

2. Don't necessarily accept the first viewpoint because that's where you stopped the car. Walk around to find one that suits the subject.

3. Compose carefully, considering foreground, background, perspective, receding features, and horizon position.

4. Seek unusual weather such as fog, approaching thunderheads, or snow squalls to breathe life into a scene.

5. You'll often want landscapes sharp from foreground to background. Use the smallest aperture possible. Don't automatically turn the focus collar until it stops at infinity just because the subject is distant.

Instead, turn it only until the markings on the lens depth-of-field scale (see p. 9) indicate infinity is within the depth of field for the chosen aperture. By doing this, you'll greatly increase the amount of sharp foreground while keeping distant features sharp.

Time of Day

Midday scenes often look commonplace and unexciting when compared to more unusual lighting conditions. Shortly before and after sunrise and sunset, the lighting is exciting. Shadows stretch endlessly, colors are muted, and the sky glows. When possible, photograph scenes early or late in the day.

Direction of Light

Sidelighting reveals texture. Backlighting stresses depth. Frontlighting shows off detail.

Use the lighting most appropriate to the characteristics of the scene before you.

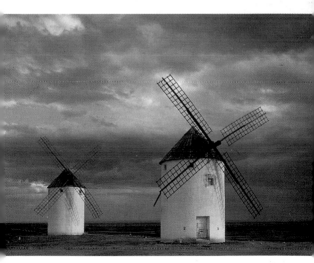

Show Something Clearly

Don't be so carried away by the scenery that you just point the camera and shoot, and expect the results to match your emotions. After your gasp of delight at what you see, calm down, and examine the scene. Choose a tree, a building, a hill, or a combination of colors as the base to build your picture on.

71

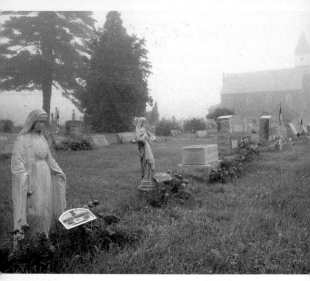

Stressing Depth

You can evoke depth by using one, several, or all of the following ideas: Frame the scene so the foreground stretches from the bottom of the frame to the background near the top of the frame. Use a small f/stop for front-to-back sharpness. With an auto-exposure camera, use the aperture priority mode or the depth-of-field program mode to choose a small aperture.

Use a wide-angle lens to exaggerate distances between near and far things. Use sidelighting or backlighting to stress shapes and planes at different distances. Use converging lines leading into the distance, such as railroad tracks, a road, or a fence.

Consider Horizon Position

See how a long horizon sends the viewer soaring into expanses of sky and a high horizon starts the viewer on a visual journey over land and water. Avoid a mid-horizon if it seems indecisive.

Be Imaginative
Don't automatically see only the realistic aspects of landscapes—the buildings, the hills, the trees. Look for abstracts. Show the sky reflected in a puddle. Show the lines of a fence, a cornfield interrupted by a belt of grass capped by a lid of blue sky.

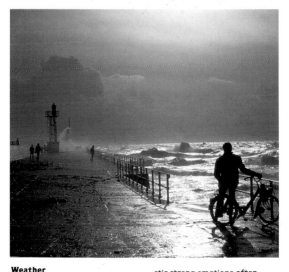

Weather
Storm clouds, curtains of rain in the distance, falling snow, all stir strong emotions often based on survival. Use unusual weather in your pictures.

SUN, MOON, STARS

Nothing is more spectacular than a fiery sunset. Nothing more breathtaking than a moonrise. Although sunrises and sunsets are photographed more than their moon counterparts, moonrises and moonsets are easier to photograph than you might think, especially when done at twilight. Both sunsets and moonrises give pleasing results with a variety of exposures. To avoid lens flare from the setting sun, keep the lens clean and if flare shows up, hide the sun behind a tree or wait for a cloud to obscure it.

SPECIAL CONSIDERATIONS

Metering a sunset. Exclude the sun from the viewfinder when determining exposure. Great underexposure may result if you include the sun in the viewfinder when metering. Instead meter the full sky adjacent to the sun —the indicated meter reading will give a silhouetted foreground and bright sky. For more shadow detail, open up 1–2 stops; for darker, saturated sky colors, close down a stop. Bracket if shooting slide film.

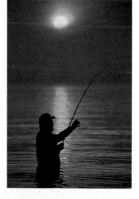

```
35 mm    50 mm    100 mm
              ·        •

   •         ●        ●
200 mm   300 mm   400 mm
```

Lens Selection △

Although a full moon and a setting sun seem enormous to the eye, to the camera neither is. To make them big in your pictures you need at least a 200 mm telephoto lens. The drawing shows the approximate image size of a setting sun or a full moon on a 35 mm frame with different focal length lenses.

Add a Foreground Subject ▽

The sun and sky alone often aren't enough for interesting sunset pictures. Include something in the foreground—a tree, a windmill, a fisherman—and if the background isn't bright, use a low viewpoint so the foreground subject silhouettes against the sky.

74

Photographing Moonscapes

You can easily photograph a moonscape at twilight when one exposure usually suffices for both the moon and the landscape. If using slide film for your twilight shooting, bracket, being sure to underexpose some shots by 1–2 stops to create the dimness of twilight.

When shooting in total darkness, the longer exposures required for the landscape will burn out the moon, and the moon may blur from its movement if the exposure is longer than a few seconds. The solution is a double exposure. The procedure for a double exposure is on p. 108, but here are a few tips for using a double exposure with the moon.

1. For the first exposure, position the moon within the frame and photograph it using the exposure in the chart on page 77. Use a telephoto lens to make the moon appear large.

2. Advance the film for the second exposure according to the procedure on p. 108.

3. Excluding the moon from the viewfinder, compose the landscape. You can use a normal or wide-angle lens if you want to include more area.

4. Expose the landscape based on the meter recommendation. If using slide film, underexpose 1 to 2 stops if you want a night-appearing landscape.

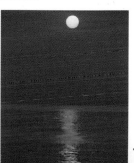

Photograph Reflections

Combine water and the sun to make a sparkling picture. You can photograph the colorful reflections in a ripple or, as was done here, you can catch the shimmering orange stripe painted on the water by the setting sun.

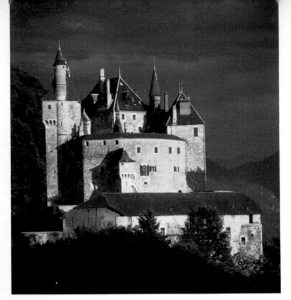

Golden Rays

Turn your back on the setting sun and study what it's shining on. Many subjects never look better than when bathed in the soft, golden rays of the setting sun. Shadows are softened, colors muted. The moment is fleeting; the picture expresses the moment.

Star Trails

To make long star trails, use a tripod and make an exposure 15 minutes or longer by setting the shutter to B and holding it open with a locking cable release.

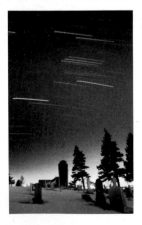

Avoid ambient light from houses and streetlights. If possible, use a wide-angle lens to increase the expanse of sky and include a foreground subject such as a tree for interest. Focus the lens on infinity. For circular trails, point the camera at the pole star. See the chart for exposure. This picture was taken 8 miles outside a medium-size city. Exposure for this picture: 20 min, $f/4$, ISO 125, 18 mm lens.

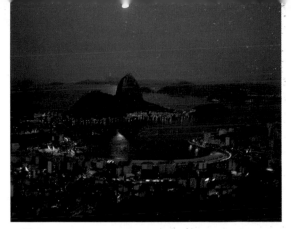

Twilight

Don't leave after the sun sets. The show is only starting. Balanced between light and dark, the twilight world glows for half an hour after sunset. With high-speed film or a tripod, you can picture the moodiness from the onrush of darkness.

General Exposure Recommendations for Astrophotography

Subject	Tripod	Film Speed	f-stop	Exposure
Star Trails	Yes	Suburban locale ISO 64	f/4	10 minutes or longer
		Rural locale ISO 64	f/2	10 minutes or longer
Meteors	Yes	ISO 64 to 200	f/5.6	30 to 60 minutes
Aurorae	Yes	ISO 200 & up	f/4 or wider	1 sec. to 2 min. depending on brightness
Man-made	Yes	ISO 200 & up	f/4 or wider	Hold shutter open for pass duration
Full Moon*	Optional	ISO 64 ISO 200	f/8 f/11	1/250 to 1/500 sec 1/500 to 1/1000 sec
Quarter Moon*	Yes	ISO 64 ISO 200	f/5.6 f/8	1/125 to 1/250 sec 1/250 to 1/500 sec
Lunar Eclipse (half shadow) (near totality)	Yes	ISO 200	f/4 f/2.8	1 sec 2 sec

*Use telephoto lens or image will be very small. Bracket exposures, especially for a rising full moon, as atmospheric haze can affect brightness greatly.

CLOSE-UP PHOTOGRAPHY

An ant as menacing as a lion, a dewdrop you could swim in. With close-up photography you can breathe life into details seldom noticed from normal viewing distances. Although built-in light meters and close-focusing lenses have simplified close-up photography, some care is still required. Rather than using the focusing ring for minute focus adjustments, you'll find it easier to edge the camera forward or backward. Increasing image size increases apparent camera and subject movement. Use a tripod if you have one. If not, hold the camera very steady, and avoid using a shutter speed slower than 1/60 second.

Focus Carefully △

In close-ups, depth of field is often less than the thickness of a finger, even at small apertures. Focus very carefully and hold the camera at that in-focus position until you've taken the picture.

Using a Teleconverter ▷

A teleconverter fits between the lens and camera. It doubles or triples image size without changing a lens' closest focusing distance and can be used for close-ups with a normal lens. To increase sharpness, use an aperture two or three stops smaller than the widest setting.

No Close-up Accessories
—Try This

You can remove your normal lens and reverse it without any accessories to take close-up pictures. Handle the lens carefully to prevent scratching it. Hold the front of the lens tightly against the camera mount. Light leaks can be minimized by encircling the lens-camera juncture with your thumb and index finger. When you reverse the lens, you lose diaphragm automation. If you

have a shutter-priority-only automatic camera, you won't be able to use this technique.

Camera Orientation for Maximum Sharpness

Depth of field is minimal in close-up photography. You can increase the likelihood of making a sharp image by holding the camera so the film plane is parallel to the subject plane.

FLOWERS AND PLANTS

Most flowers are photographed for their colors. Other plants are photographed for their shapes. Close-ups of individual flowers or clusters of flowers generally work best because they reveal details. To render subtle hues, avoid harsh front sunlight. Diffused light from shade or an overcast day preserves the widest range of hues. For many flowers, backlighting not only makes the petals seem to glow but strongly defines shape.

Wind is the enemy. The slightest breeze can stir a flower head, blurring the photograph. If you can't wait out the wind you have three options: Use a jacket or sweater as a windbreak; use a fast shutter speed, more easily obtained with high-speed film, to freeze any flower movement; use electronic flash to freeze flower movement. If necessary, you can immobilize the flower by guying it with sticks and thread.

Composition and Viewpoint

Consider composition and viewpoint carefully. Many flowers look best when taken from flower level. A viewpoint from below the flower may work well as it shows the flower stretching skyward. To photograph this cluster of Pasque flowers, the photographer used a low viewpoint that let him include the out-of-focus sun.

Using a Reflector

You can lighten shadows on a small plant or model one side by using a reflector to redirect the light.

A small piece of white paper, a white envelope, the pages of this book, or even the palm of your hand can reflect light. A square foot of mat board, white on one side and black on the other, can function either as a reflector (white side) or as a background (black side).

Dew or Spritzer

On clear, cool summer and fall mornings the world is misted with dew. Dew adds sparkling highlights and a freshness befitting flowers. Carry a small spritzer bottle so you can add your own dew when the real thing is absent.

Unusual Shapes and Forms

When isolated, the unusual forms and shapes of many plants create strong photographs. Silhouettes made by underexposing backlighted subjects stress shape as can strong frontlighting. Sidelighting enhances form and texture. Diffused toplighting shows the forms of these mushrooms.

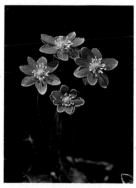

Control the Background

Many flower photos benefit when the background is darker than the flower. If you can't find a naturally shaded background, use a black cardboard or have a companion cast a shadow behind the subject. Using the depth-of-field preview button, inspect the background for distracting shapes or highlights.

INSECTS

Insects fly, fight, poison, plot and do all the other carryings-on that make for good drama. Knowing an insect's habitat, favorite foods, and behavioral patterns will increase your chances of success. A meadow on a summer morning is a good place to find a wide variety of insects. Since many are well camouflaged, poke through the brush and observe carefully. Others, garishly marked to warn predators they are poisonous or bad tasting, are found more easily. Close-up accessories are generally necessary to obtain a large image of a small insect. For wary insects, you can increase your working distance by using a teleconverter or a telephoto lens attached to an extension tube.

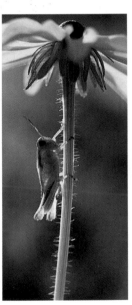

Tell a Story

Hunt for insects laying eggs, capturing prey, mating, feeding, or metamorphosing. Try to show significant stages in life cycle. Here praying mantises emerge from their egg case.

Work Quickly

Some insects are slow and plodding. Others are fast and darting. Whether plodding or darting, they all move and may hold that best of poses only momentarily—so be prepared.

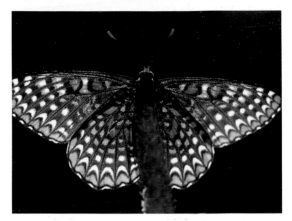

Backlighting

The wings of insects, like butterflies and moths, seem to glow when backlit. A stand of trees forms a dark background for this backlit checkerspot butterfly.

Early Morning

After a cool night, insects warm up slowly and will be sluggish enough to photograph more easily. Search dewy fields to find butterflies climbing grass stalks to spread their wings and absorb the sun or comatose bees clinging to flowers.

Stake Out a Food Spot

If stalking an insect turns into a breathless chase, try staking out its favorite flower or food. Choose a position with a favorable background, focus, and wait patiently for your subject to arrive.

WILD ANIMALS

Photographing truly wild animals is a delicate task because they are wary. Use of a blind or a remote release is often a necessity. The photographer must know the quarry's feeding, watering, mating, and sleeping habits and how to attract animals or at least avoid scaring them. Many animals in or near parks, game reserves, and suburbia are semitame, and their whereabouts are better known, so you can more easily approach them.

The item most important in photographing animals is a telephoto lens in the 200 to 500 mm range to give you a large enough image when you can't get close to your subject. Because of shallow depth of field, a telephoto lens requires careful focusing. A steady hand, along with a fast shutter speed, will help minimize blur caused by camera shake. If you aren't using a tripod, use a shutter speed of 1/over lens focal length or faster to prevent blur from camera shake.

Use a Car as a Blind

Hawks, deer, pheasants, and other animals often ignore cars, even slowly moving ones. Minimize your movements inside the car, and turn off the engine before shooting so vibrations won't cause blur from camera motion.

Bring Food or Head for Food Sources

Sea gulls, park squirrels, ducks and other semitame animals can be lured almost immediately with an offering of food. For wilder animals, you might want to seed an area with food for several days or at least a few hours ahead of time before you set up to take pictures.

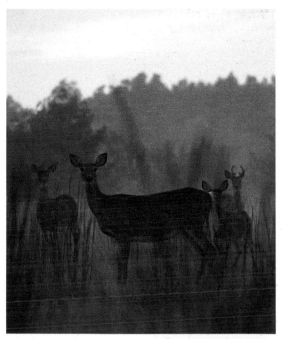

Be There at Dawn and Dusk

Many animals feed and roam early and late in the day. Those are the times you should be out with your camera. Take high-speed film or a tripod to avoid or counteract slow shutter speeds common to existing-light photography.

Action Techniques for Animals

When photographing animals, consider action techniques like panning and stop-action that reveal the grace, speed, or fury of an animal. In these shots the photographers used flash to freeze a pair of birds and panned a Uganda kob to convey its speed and agility.

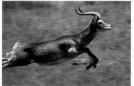

ZOOS

Zoos offer you the chance to photograph animals from all over the world. With more and more zoos presenting their animals in natural-looking environments, your photographs will seem to have been taken in the savannas of Africa or the steppes of Russia. Confined animals, including birds, often establish a definite route of movement. Observe it, then prefocus on the spot where the animal looks best. Preset exposure, and snap the picture when the animal reaches the spot. Whistle to make the animal look at you.

SPECIAL CONSIDERATIONS

Color Balance. Indoor displays may have fluorescent lighting that often imparts a green tinge to pictures taken with color daylight film. If you lack the correct filtration (p. 39), use flash and/or high-speed color negative film or black-and-white film. With flash and, to some extent, with color negative film, you can overcome color shifts from an incorrect light source.

Lens Selection. Take along a normal or wide-angle lens and a telephoto or telephoto zoom lens so you can take both overall shots and frame-filling shots of distant animals.

Autofocus. If you're using an autofocus camera, the lens may focus on the fence or bars and not the subject behind them. To overcome this, switch your camera to manual focus. You may have to do the same if you're photographing through glass—the camera may focus on surface reflections. If you're using an auto-exposure camera, select the aperture-priority mode and use the widest possible lens aperture.

Disappearing Bars

You can make chain link fences and cage bars almost disappear by using a telephoto lens at a wide aperture and standing within roughly 20 inches (0.5 m) of the barrier (but out of harm's reach of grabby animals). Make sure no bar or wire is in the center of the lens field. Use the depth-of-field preview button to check the effect. This photo was taken with a 200 mm lens set at $f/4$.

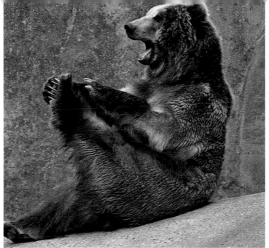

Feeding Time

Feeding time for animals is prime time for picture-taking. Anticipating food, animals grow restless and begin pacing, growling, and wheeling about, offering you many photographic opportunities. Call the zoo ahead of time to check the feeding schedules.

Animals Behind Glass △

Reflections and dirt on glass degrade images. If permissible, clean a small area of glass to photograph through. Hold your lens flush against the glass to eliminate reflections. If you can't get that close, stand at an angle to the glass and use a polarizing filter to reduce reflections.

Poignant Expressions △

You can make poignant photographs by showing the dilemma of a confined animal.

ARCHITECTURE

A single building lends itself to many photographic inter-
pretations. Light, weather, surroundings, and camera angle
all influence the appearance of a building. Choose these com-
ponents carefully to complement the style, history, function,
and mood of your subject. Find what is special about the
building. Its height? Shape? Color? Function? Strive to show
key features. Don't treat Druid ruins as you would a sky-
scraper.

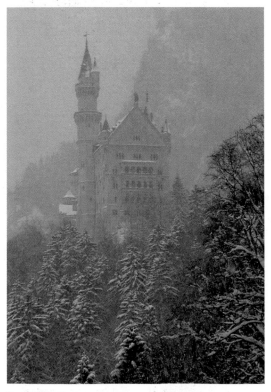

Unusual Weather Lends Drama
Unusual weather animates
many architectural photo-
graphs. Brooding skies, stream-
ing clouds infuse architectural
photographs with a quality
sometimes surly, sometimes
pensive but always exciting.

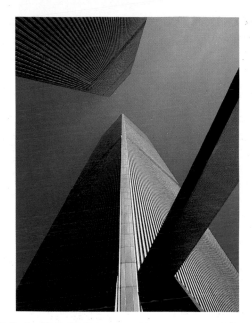

The Good and Bad of Extreme Perspective

Tilting the camera upward to include the top of a tall building causes vertical lines to converge on the picture, especially noticeable when using a wide-angle lens. This extreme perspective effect makes skyscrapers seem to zoom into the upper reaches of the sky, an effect that can be breathtaking. To reduce convergence, shoot from a position that lets you level the camera and avoid pointing it upward. For example, move to a higher or more distant location to reduce camera tilt. Or don't show the top of the building.

Lighting

The direction of light is of utmost importance in revealing two major characteristics of any building: form and shape. Front-lighting and backlighting show shape best. Various angles of sidelighting show form best, creating shadows that define the planes of a building and its depth.

Haunting Twilight

A glass-walled building reflects a golden sunset, yet glows from interior lights—a transformation from its daylight facade. Use time of day to your advantage when photographing buildings.

Darkening the Sky

For medium- and light-toned structures you can create dramatic contrast between the building and a blue sky by using filters. For color and black-and-white film, a polarizing filter darkens blue sky. For black-and-white film, a No. 15 deep yellow, a No. 21 orange, and a No. 25 red increasingly darken blue sky.

Importance of Surroundings

Many buildings integrate with their surroundings. Isolating them from their site may mock the architect's intent. Choose a viewpoint that uses significant surroundings to reveal more about the building. Here the photographer gave Big Ben an aristocratic aura by framing the tower within an ornate gate.

Details

Architecture is a science of details. Details can reflect the period and style of the building, and often make better subjects than the overall building.

Photographing Interiors

A wide-angle lens and high-speed film aid in recording interiors using the existing light. To provide more even lighting over the depth of a room, use bounce flash. Keep in mind that colors will shift if you mismatch film type and light source without using appropriate filtration.

SPECIAL OCCASIONS

Birthdays, graduations, weddings, and bar mitzvahs are special because they signify a high point or transition in someone's life. Photographs of such events assume an emotional importance as a nostalgic remembrance of that special day.

Because many ceremonies are formal, solemn, and progress rapidly, you won't often get a second chance for a shot. So be prepared. Scout the location ahead of time, checking for lighting (tungsten or fluorescent need special care for good color balance), potential camera angles, and any unusual problems. Find locations that give good viewpoints yet allow you to be unobtrusive.

SPECIAL CONSIDERATIONS

Responsibilities. If possible, avoid being the sole "official" photographer unless you are very confident of your abilities.

Lighting. For indoor events decide whether to use electronic flash or rely on existing light. Existing-light photography preserves the atmosphere but if the light is too dim, you risk lower picture quality because of underexposure and camera shake. When in doubt, use electronic flash with fresh batteries (carry extras) along with high-speed film.

Check in advance to make sure there will be no objection to flash use in houses of worship or during ceremonies.

Film. Take more film than you need. Four or five rolls of 36-exposure film should suffice, but if you're a prolific shooter take more; you can always use it later.

High-speed film permits automatic flash units to recycle rapidly so you will miss fewer shots. High-speed negative film has greater exposure latitude than slide film, thereby yielding a higher percentage of good exposures in difficult lighting.

Lenses. Take a telephoto zoom lens or a wide-angle-to-telephoto zoom lens and a normal or wide-angle lens if you have them.

The zoom lens will let you frame scenes easily without maneuvering in a crowd. The wide-angle lens will be useful for overall scenes, especially indoors. With a fast normal lens you can easily take existing-light shots.

Shoot Over the Crowd

If you're stuck in a crowd you can stretch your arms overhead and point the camera down to take a picture. Use a normal or wide-angle lens to be sure of including your subject.

MAKE A PICTURE STORY

Most special occasions have a
definite progression you can doc-
ument. Build up excitement by
starting the story with the prep-
arations. Follow it through to
the departure of guests.

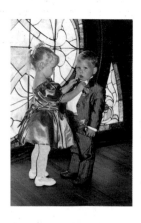

Candid Shots

Don't worry about posing your
subjects. Simply wander unob-
trusively, camera ready, and
snap a picture whenever you see
an interesting scene. Seek out
the youngest and oldest guests,
and watch for incongruities.

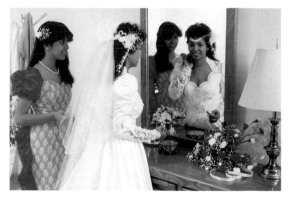

Go Behind the Scenes

Everybody knows what happens
up front, but they can only guess
what's going on behind the
scenes. Ask for permission to go
behind-the-scenes and photo-
graph the ushers inviting the
groom to attend his own wed-
ding, or pinning on bouton-
nieres, or the bride sprucing up.

93

Photograph Details

Any special occasion has symbolic details. Take a close-up of a diploma clutched in a hand, of the rings on the hands of newlyweds.

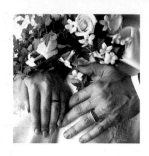

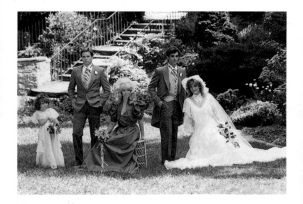

Group Shot of the Participants

The only posed shots you may need are of the key participants together. They are the cast of the story, and a group shot shows them as the leading characters. Moreover, there are close bonds between them so they will appreciate photographs showing them all together.

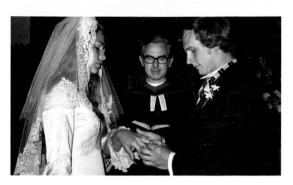

Capture Key Moments

Get in position ahead of time. Make sure you have a good view-point. Prefocus on the scene, and have all camera settings ready.

TRAVEL

Travel presents you with a rare chance to feast on a photographic smorgasbord. You'll sample fare like rugged canyons and sparkling seashores, famous landmarks and local eateries. Don't skimp on film. It's the cheapest part of a travel budget and you'll nearly always need more than you anticipate. Give some thought to your picture-taking before you leave on the trip. Review equipment needs (see suggestions on p. 98) and photographic techniques for landscapes, people, nature, and action. Unless you have to, don't travel with a brand-new camera you've never used. Unfamiliarity with a camera might lead to disappointing results. If you do buy a new camera or other equipment, use it before departure, and take the instructions with you.

Meeting schedules. Making reservations. Reading maps. Entertaining children. Although travel can be hectic, the memories are almost always pleasant. By approaching photography in two different ways you can lighten the cares of travel while taking pictures.

First, look at your vacation picture-taking as a diary of your adventures and misadventures: the flat tire, the endless restroom trips, the attack by monster mosquitoes. Not only can casual picture-taking convert such trying times into light-hearted moments but you'll also end up with an accurate journal of what your trip was really like. Second, strive to make creative pictures that show the uniqueness of the place—customs, dress, landscape.

If you really don't have the time for creative pictures, don't worry about it. Relax, take snapshots, and enjoy yourself. A photograph doesn't have to be a work of art to be a treasured memento.

SPECIAL CONSIDERATIONS

Preparations. A month before you leave, load the camera and flash with new batteries. Expose and process promptly a roll of test pictures to check for correct camera operation.

Buy spare batteries for the camera and flash.

Check that your photographic equipment is covered by your homeowner's insurance or buy a camera policy.

X-rays. Airline x-ray equipment can fog unprocessed film. The effect of x-rays is cumulative. Carry-on luggage is always x-rayed and checked luggage is often x-rayed.

Special care should be given to very high speed films rated at ISO 800 or higher; they should not be exposed to x-rays. They should only be visually inspected. Other films can sometimes be x-rayed. In the United States, fewer than five x-ray inspections should not visibly fog other Kodak films. But more powerful x-ray equipment used in some overseas airports can fog film in one exposure. What can you do to avoid fogging from x-rays?

a. Pack film in a clear plastic bag. Carry film and loaded cameras in hand luggage, packed so it can be easily and quickly separated from other items. Arrive early at the airport and ask for a visual inspection of film while allowing other items to go through x-ray inspection.

Stress that x-rays may damage your film. Not all inspectors will cooperate, but most will.

b. If film must remain in your bag for several inspections, reorient the film each time you pack the bag so x-rays don't repeatedly penetrate it via the same path. Or reorient the bag each time it passes through x-ray inspection.

Customs. If you're going abroad, register your photo equipment with US Customs before you leave. Carry the registration certificate with you. When you return, the registration proves to Customs inspectors that you didn't buy the equipment overseas during your trip. International airports have registration offices but take lots of time.

Military installations. When abroad, don't photograph military or research installations, and don't attempt to sneak pictures in restricted areas where photography is prohibited.

Equipment. If you'll be walking a lot, travel light. The weight of the bag increases in proportion to the time carried. If you don't plan on much walking, take all the equipment you can't bear to leave at home. Either way, take a backup camera. An extra camera body that takes the same lenses as your primary camera is best, but even a simple point-and-shoot or one-time-use camera will do.

Cont. next page

Riders

Two 35 mm cameras (one will serve as a spare)

Flash unit

Normal lens, telephoto or telephoto zoom lens, macro lens and wide-angle lens (for interiors)

Tripod

Filters

Cable release

Lens tissue

Camel's-hair brush

Extension tubes (unless you're taking a macro lens)

Walkers

2 cameras (a 35 mm camera and a pocket camera)

Small flash unit

Normal lens, zoom lens and wide-angle lens (for interiors)

Filters

Lens tissue

Compact tripod

Extension tubes (unless you're taking a macro lens)

Film. Take lots of film, particularly if you may not be able to buy film at your destination. Include high-speed film for night and indoor photography (museums, especially). Before going abroad, ask the country's consulate or embassy if there are restrictions on the amount of film you can take into the country. Film restrictions are sometimes overlooked for tourists but may be enforced or be stricter for professional photographers.

Research Your Destination

Before leaving home, study your destination through travel brochures and books. Make a list of unusual sights, buildings, and festivals. This photographer planned his trip to Japan around the Snow and Ice Festival held in Sapporo.

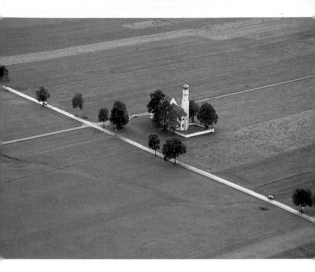

Pictures From a Plane △

In a commercial plane, choose a seat next to a clean window well ahead of or behind the wing. If the plane is taking off or landing, use a shutter speed of 1/250 second or higher and pan the camera with the subject. Once the plane is in the air, you can use a shutter speed of 1/125 second or higher.

Set the camera at infinity and hold it near but not quite touching the window. If you use a telephoto lens, set the shutter at 1/500 second or faster.

You can also take pictures inside the plane as you would in any similarly lighted interior. Do not let the camera touch any part of the plane or vibrations may blur the picture.

If flying in a light airplane below 2000 ft (300 m), use a 50 mm lens focused at infinity and a shutter speed of 1/250 second or faster.

Pictures From a Moving Car, Train, or Bus—It's Easy

If you can't stop, you can still take a picture. Here's how.

1. Set the shutter speed to 1/250 second or higher (1/125 second in a pinch), and live with the required aperture.

2. Open the window or press the lens up to but not quite touching the window to avoid reflections from the glass.

3. Photograph the subject before or after passing it to minimize motion blur.

Journal of a Trip

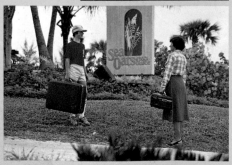

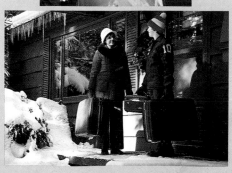

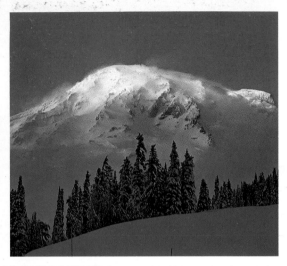

Seeing Through Emotion

The inspiration you feel at the sight of majestic mountains and rugged seashores isn't automatically transferred to your pictures. Analyze the scene. Photograph it with care and thought. Even the grandest of subjects requires careful composition to make a successful photograph.

Keep Your Camera Ready

The photographer got this shot only because he had his camera with him and was prepared.

Before leaving your hotel, set the aperture at $f/11$ and the focus distance at 16 ft (5 m), giving a depth of field from 11 to 30 ft (3 to 9 m), a range at which many pictures are made.

People Are the Country

Don't just photograph famous or scenic places. Photograph the people. They are the soul of a country. Their dress, customs, and crafts make good subjects.

Visit Markets for Variety

Local markets are good places to find interesting subjects. Go early and photograph the merchants setting up their displays for the day.

WEATHER

There's more to outdoor photography than blue skies and brilliant sunshine. There are dark clouds swarming over the horizon, snow snaking through corn fields, fog veiling the seaside. So important yet so uncontrollable, weather easily evokes strong and varied emotions. It can mean life or death, joy or despair, excitement or tranquility. Use the weather to elicit strong responses to your photographs. Photographs of landscapes and architectural subjects especially benefit from unusual weather.

SPECIAL CONSIDERATIONS

Yourself. If drenched by rain or frozen by the cold, you won't feel like taking pictures. Dress appropriately. A waterproof poncho or other foul-weather gear for rain; layers of clothes and warm boots and gloves for cold. Choose handwear that suits you best for warmth and dexterity. A knit mitten on the left hand lets you focus, while a thin glove on the right hand lets you adjust controls and press the shutter release. It may look odd, but it's practical for photography.

Water and Your Camera. Water is the enemy of cameras, especially electronic automatic cameras. In wet conditions, protect your camera. You can keep it under your coat except for the brief moments when using it, or you can place it inside a plastic bag with a hole cut out for the lens. Have a towel handy to dry the outside of the camera.

Cold and Your Camera. Cold quickly saps batteries of power. Normally the small batteries for the exposure system will endure (carry spares just in case), but the batteries for flash and motor drive may not. The heavy power drain on them takes its toll. Carry spare batteries for accessories in your coat or pants pocket to keep them warm.

Don't take an unprotected camera from subfreezing weather to the warm indoors or condensation may form on the exterior and interior of the camera body and lens. Before going indoors, place the camera in a plastic bag, squeeze out the air, and seal the bag.

If you don't have a plastic bag, use your camera bag and zip it shut. After half an hour indoors, you can remove the camera from the bag.

In extremely dry, cold air, film becomes brittle and susceptible to breakage and to static marks when advanced rapidly. Advance and rewind film slowly under such conditions. To prevent film breakage and static marks, don't use a motor winder in severe cold.

Film in Hot and Humid Conditions

Prolonged high temperatures can alter the color balance of both color negative and slide films and can adversely affect black-and-white films, too.

The hottest place you're likely to come across is your parked car on a warm, sunny summer day—the temperature can quickly reach 140°F (60°C). Don't leave your film in a parked car on a hot, sunny day. If unavoidable, park the car in the shade, or store the film in an ice chest.

Supplied in vaportight packaging, Kodak films require no additional protection against high humidities until you open the package. Don't open the vaportight film containers until you are ready to use the film. Once you have exposed the film, return it to its container to protect it from excess humidity.

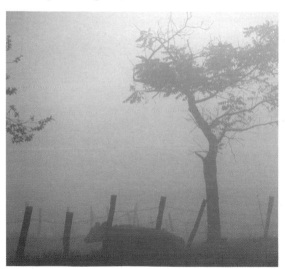

Fog

Solitude and loneliness, melancholy and serenity, the cry of a loon, the reverberation of a foghorn. Shapes dissolving into ghostly shadows, details disappearing. Such is the feel of fog.

Look for large subjects like barns and trees that shoulder their way through the fog. Increase exposure ½ to 1 stop as the brightness of fog misleads the meter into underexposure.

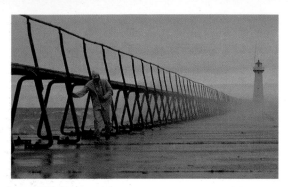

Intensifying Storms

An approaching storm darkens the sky. The stronger the storm the darker the sky. With slide film, you can seemingly inten-sify a storm by underexposing ½ to 1 stop. Waves, people, fields of crops, and trees are buffeted by the wind. Use them to show the force of a storm.

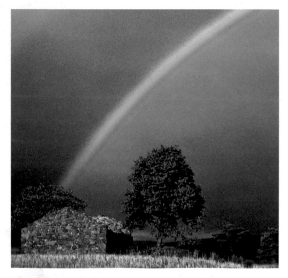

Rainbows

Determine exposure by metering the sky next to the rainbow. To record the subtle colors of a rain-bow try a half to a full stop underexposure with slide film and normal exposure with nega-tive film.

Exposing for Snow

To people, snow is white. To exposure meters, it is gray. To get the snow white, increase the meter's recommendations by ½ to 1½ stops. Bracketing is also recommended.

Blah Days

Leaden skies oppress the soul, making even the most diehard photographer want to call it quits. Don't. The sky at its worst, brings out the best in many other things. The overcast sky acts as a giant diffuser that creates soft light which is ideal for portraits and nature subjects. In portraits, the skin appears its softest and smoothest. In nature, colors show off their widest range of hues.

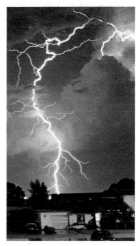

Lightning

Lightning shots look best when some foreground is included. They're easier to take at night because you can use longer exposures to catch several flashes on a single frame of film.

For day or night shots, use medium-speed film, a tripod, and a locking cable release. Use a normal or slightly wide-angle lens so you have sufficient coverage to increase your chances of catching lightning. Point the lens at the heaviest concentration of lightning. Focus on infinity, set the aperture at $f/16$, and the shutter at B, and hold it open with a locking cable release.

At night, use an exposure of 5 minutes. During the day, let your meter guide your exposure and keep shooting until you've caught lightning streaking across the sky when the shutter was open. Take shelter when the storm nears.

SPECIAL EFFECTS

When the scene before you seems lacklustre or when a whim strikes you to experiment, then you're ready for special effects. In a photograph, special effects call attention to themselves by changing the appearance of a scene in a way possible only through photographic tampering. The change might be as simple as adding a color cast with an orange filter or it might be more complex, such as making 8 exposures on the same frame of film. Special effects have a tendency to appear gimmicky, which is alright if you only want a change of pace. But if you want to enhance the subject, use special effects thoughtfully and sparingly.

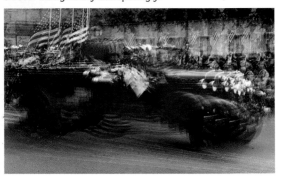

Multiple Exposures

Multiple exposure lets you superimpose two or more images on the same frame of film. You can move the moon where you want it or sail a boat across the sky. In the above shot, 6 exposures were made using a motor drive.

Decrease exposure according to the table below so that the multiple exposures add up to a correct exposure. Some cameras have a multiple-exposure control. If your camera has one, follow the operating instructions in your camera manual. This control lets you recock the shutter without advancing the film.

If your camera lacks a multiple-exposure control, try this after the first exposure.

1. Hold the rewind knob on top of the camera immobile.

2. Depress the rewind button on the bottom of the camera.

3. Stroke the film advance lever to recock the shutter as you continue to perform steps 1 and 2. Don't force the lever if it resists.

4. You're ready for the second exposure.

Multiple Exposures

No. of Exposures	Exposure Decrease (stops)
2	1
3	1½
4	2
6	2½
8	3

108

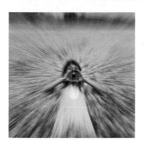

Zoom Effects

Changing the focal length of a zoom lens smoothly but rapidly during a relatively long exposure can produce unusual effects on film. With skill and luck, zooming creates a photo that seems to explode with light and color.

It works best with a simple subject against a background with some variation in color and contrast. A bright subject against a dark background can benefit from the technique.

Since exposures should be 1/15 second or slower, choose a film with a speed appropriate to lighting conditions. Use a tripod if you have one. Here's the procedure.

1. Use a shutter 1/15 second or longer.

2. Focus on the subject with the zoom set at the shortest focal length (for example at 80 mm for an 80 to 200 mm zoom lens).

3. Just before or just as you press the shutter release begin moving the zoom control fast enough to cover the range of focal lengths while the shutter is open.

Soft Focus

Soft focus photography lends a dreamy mood to pictures by flaring highlights and obscuring details. If you don't have a diffusion filter, you can improvise soft-focus devices.

You can stretch a neutral-colored mesh stocking over the lens. You can place an X of transparent tape across a skylight or UV filter (not across the lens surface).

You can hold wrinkled cellophane in front of the lens. You can smear clear petroleum jelly or clear nail polish on an old skylight filter (leave a ⅜-inch (9.5 mm) bare circle in the center). You can even fog the lens with your breath if you shoot before the mist evaporates.

Heighten the soft-focus effect by using apertures between $f/2$ and $f/5.6$. Diffusion effects increase at wide apertures and decrease at small apertures. Use the depth-of-field preview button to see the effect at different lens settings.